THE
Archive Photographs
SERIES

DORCHESTER

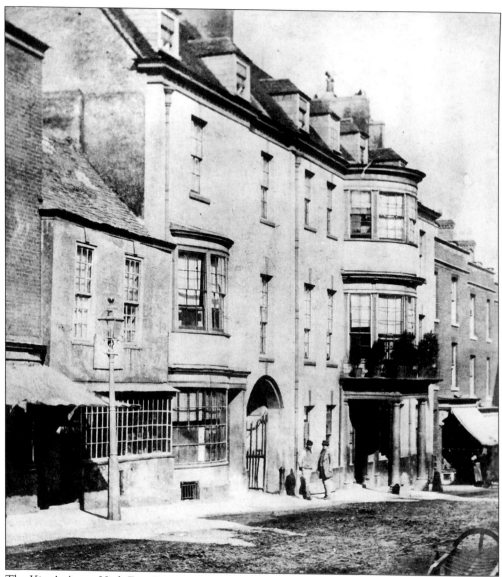

The King's Arms, High East Street, c. 1855 to 1860. An early photograph, taken at just the time Thomas Hardy set *The Mayor of Casterbridge*. In the novel, the mayor's dinner is held at the King's Arms. The fine two-storey bay window supported on pillars is part of an early nineteenth century rebuilding of the street front. Dorchester was an important coaching centre, and the King's Arms was one of the important coaching inns. The last coach ran in November 1860, to Blandford. *The Dorset County Chronicle* recorded that the coachman 'who has weilded the whip ever since it was thought a good thing to reach London in twelve hours' would have to look for a job 'where the iron rail' did not exist.

THE
Archive Photographs
SERIES

DORCHESTER

Jo Draper

TEMPUS

This book is dedicated to the many people who have,
over the years, given photographs to the Dorset County Museum.
Without them, this book would not have been possible.

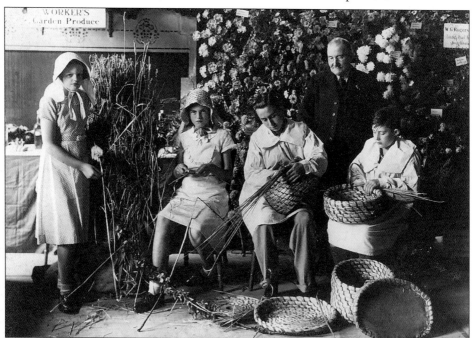

Part of the Dorchester Agricultural Produce Exhibition, 1935. From left to right: Betty Curtis, Audrey Highmore. Maurice Batten and John Archer demonstrate making containers from bound straw, like bee skips. Three thousand people visited the three-day event which displayed many products including bacon, eggs, watercress, cheese, beer, hand-woven woollen cloth and loaves from Dorset wheat. Worker's garden produce was shown in another section.

First published 1997, reprinted 2005

Tempus Publishing Limited
The Mill, Brimscombe Port,
Stroud, Gloucestershire, GL5 2QG
www.tempus-publishing.com

© The Dorset County Museum and Jo Draper, 1997

The right of The Dorset County Museum and Jo Draper to be identified
as the Author of this work has been asserted in accordance with the
Copyrights, Designs and Patents Act 1988.

British Library Cataloguing in Publication Data.
A catalogue record for this book is available from the British Library.

ISBN 0 7524 1023 7

Typesetting and origination by Tempus Publishing Limited.
Printed in Great Britain.

The Church Lads
Brigade Parade in
High West Street
on Empire Day,
c. 1900 to 1910.
In 1901 more than
seventy boys joined
the parade, and
'their smart
appearance was
much remarked on'.

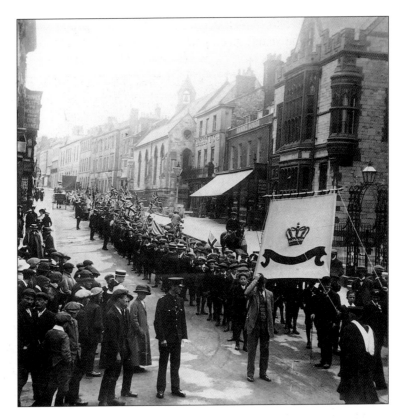

Contents

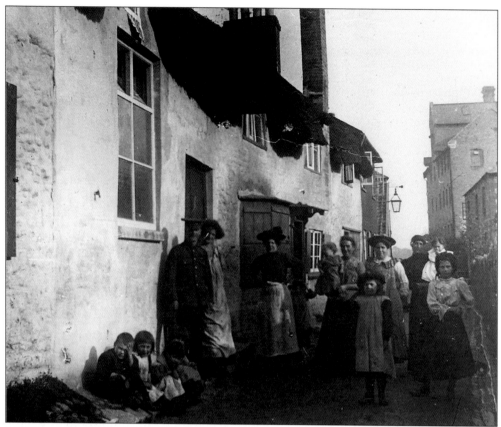

Mill Street, Fordington, about 1900 to 1910. Fordington Mill is on the right in the background. This was the most crowded part of Dorchester, and most of the cottages were to be demolished in the 1930s in a slum clearance scheme.

Acknowledgements

I am very grateful to the Dorset County Museum for allowing me to use their collections, and especially thank Val Dicker for all her help. Christopher Chaplin has kindly read drafts of the text, and The Keep Military Museum, Dorchester advised me on one of the photographs. I also thank those who have given me photographs of Dorchester to copy and Sheena Pearce who has word-processed everything so kindly and efficiently. The Veteran Car Club of Great Britain kindly identified the cars on pages 82 and 83. The Dorset County Library has helped me with endless queries, and I am grateful to all the staff there.

Four recollections of Dorchester have been used extensively in the text. Miss C. M. Fisher's *Reminiscences of life in Dorchester 60-70 years ago* (1961); T.C. Newman's *A Dorchester Pendulum* (1937); 'Old Dorchester – Recollections of High-West Street-l', an anonymous article in *The Dorset Daily Echo* 21 May 1921 (called 1921 recollections in the text); and 'I remember' by An Old Durnovarian, in *Dorset County Chronicle* 1 January 1931 (called 1931 recollections in the text). Details of the wool sales are taken from an article by H.O.B. Duke in *Proceedings of the Dorset Natural History & Archaeological Society* vol. 108 (1986). All unattributed quotations are from the *Dorset County Chronicle*.

Dorchester
1850s to 1950s

Dorchester in the 1850s was a compact county town still very much the same size and shape as the medieval town, and still enclosed by the line of the Roman defences, 'a place deposited in the block upon a corn-field. There was no suburb in the modern sense, or transitional intermixture of town and down. It stood clean-cut and distinct, like a chess-board on a green table-cloth' (Thomas Hardy). The sharp break between town and county was blurred only on the east, where the rural village of Fordington adjoined the town's High Street. The cornfields abutting Dorchester on two sides were the open fields of Fordington, still being worked in the medieval communal way in the 1860s. All Fordington's farmhouses and barns were actually in the village, because the fields were open and not cut up into farms. Miss Fisher remembered late nineteenth century Dorchester as 'certainly a town of trees. Besides the Walks [on the line of the Roman defences] there were avenues along the Bridport Road, Cornwall Road, London Road and Weymouth Road'. These avenues along the three main roads into the town stood out prominently in the cornfields of Fordington and across the watermeadows.

Thomas Hardy drew on his memories of being at school and training as an architect in the town for *The Mayor of Casterbridge* (quoted above). The novel was published in 1886, but is set in the Dorchester of the 1850s. The main shopping street was then the High West and High East Streets, but the arrival of the railway in 1847 was shifting the emphasis of the town to South Street because that was the main way into the town for those who arrived by train.

The enclosure of Fordington's open fields in 1876 meant that it was possible to extend the town outside the Roman defences. Large areas of redbrick terraces were quickly built to the south and west, leaving only the north side of the old town bounded by countryside and watermeadows.

Fordington changed from an agricultural village to a suburb as new farms were built out in the fields. Brick terraces were built in Fordington, and most of the old barns and farmhouses disappeared. Several new industries were established, and old ones like brewing built large, new premises. Many more shops opened in the town, and much rebuilding took place. The centre of the town reached its present appearance by 1900.

In the early twentieth century, the roads became important again with the spread of motor cars and lorries. Dorchester in the 1920s and 1930s seems unsure whether it wanted to be the old-fashioned town of Casterbridge, or a

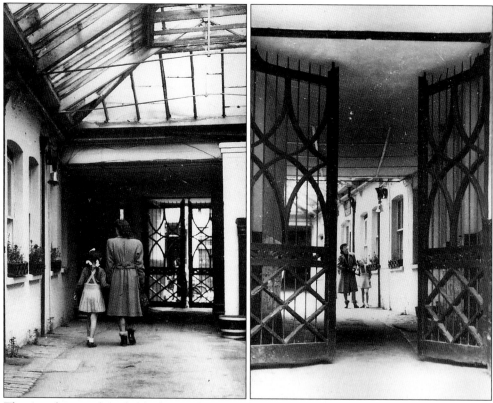

The Antelope yard, probably during the Second World War. The stables and coach houses had been some of the busiest in Dorchester, since the Antelope was a major coaching inn. By the 1940s the horses were long gone. The fine early nineteenth-century gates still survive.

modern, up-to-date commercial centre. The town continued to grow further out into the countryside, but in the 1930s the development was more likely to be semi-detached houses than terraces.

Since it was a barracks town, Dorchester had been important in the First World War, but the second had much more effect on the inhabitants. Happily, since only a few stray bombs fell on the town, the Second World War had little effect on the town physically. The line for the Dorchester bypass was set aside from the late 1930s, but in the 1950s the traffic still all went through the middle. In some ways the town was still like that of 1850: most of the businesses were locally owned, and supermarkets had yet to arrive. Three or four independent family grocers supplied the town's basic foods, along with many more butchers. Crafts like saddle-making, tailoring and printing were carried out in the town centre. The industrial estates on the outskirts were only just beginning: the multiple stores were arriving; and the first shopping arcade was about to be built. Dorchester was changing from Casterbridge to the town we know today.

Jo Draper
September 1997

One

Casterbridge
The Town in the 1860s

'Casterbridge was the complement of the rural life around; not its urban opposite. Bees and butterflies in the cornfields at the top of the town, who desired to get to the meads at the bottom, took no circuitous course, but flew straight down High Street'.

Thomas Hardy in *The Mayor of Casterbridge*

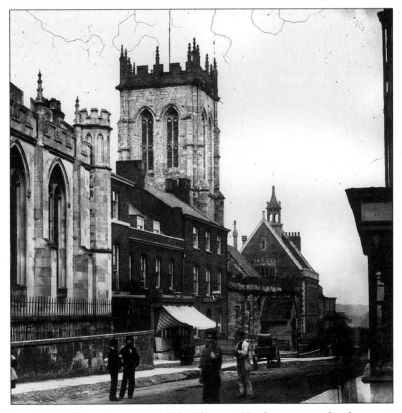

Looking down High West Street, *c.* 1860. Thomas Hardy was at school or training as an architect in Dorchester for twelve years from 1850. He must have known every nook and cranny. His novel *The Mayor of Casterbridge* is set in the town in the 1850s.

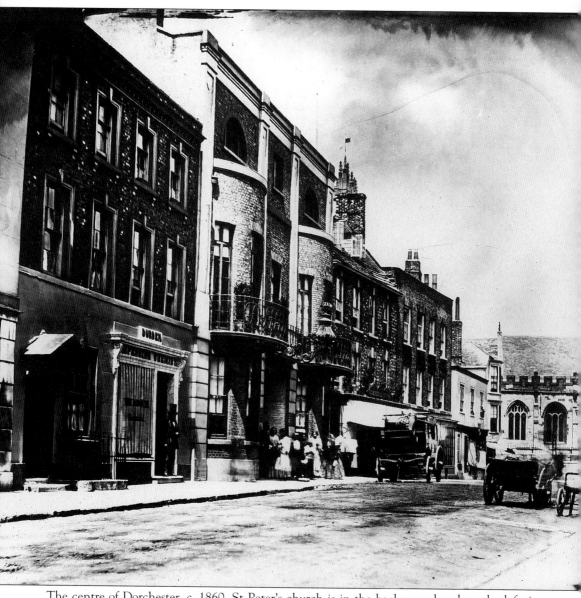

The centre of Dorchester, *c.* 1860. St Peter's church is in the background and on the left, in Cornhill, with the shallow bay windows is the Antelope Hotel, one of several coaching inns in the town – a carriage is parked outside. Dorchester had been an important junction on several coaching routes, but with the opening of the railway to the town in 1847 trade was declining for all the coaching inns. The 1859 *Directory* states that 'Omnibuses are constantly at the station from "King's Arms" and "Antelope" to meet all the trains.' Only one coach (to Blandford) was still running, so the inns had to change to fit in with the railways. Even in 1851 the Antelope's advertisement was emphasising its role as a hotel: 'domestic comforts of a home' offering 'superior advantages to families, tourists and others, while to commercial gentlemen and agriculturalists this hotel has long stood pre-eminent'. The man in the top hat standing in the shop doorway could be Henry Durden since the premises were his chemist and druggist shop. Most of the Georgian brick buildings here have been demolished and replaced, but the Antelope survives.

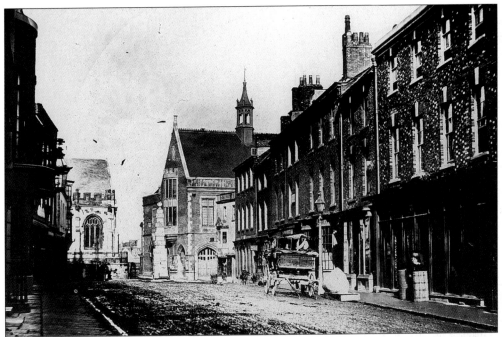

The east side of Cornhill, *c.* 1860. In the background are St Peter's church on the left and the town hall of 1848 on the right. The town pump in the middle was built in 1784. The shop to the right was a cabinet maker and furnishers: the man standing outside seems to be holding rolls of carpet.

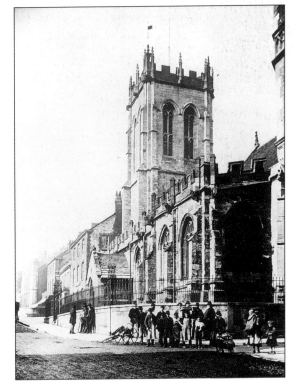

St Peter's church, *c.* 1860. The late medieval building looks much the same today externally, but inside it has been rather changed. Thomas Hardy helped with the first restoration in 1856, when he was a pupil architect in the town. The town looks very peaceful, but this was the site of a riot in 1864, when the borough police tried to stop the annual rolling of flaming tar barrels down the High Streets on 5 November. The mob (many disguised by 'grotesque costumes') turned on the police who retreated into the town hall, and the tar barrels rolled for the last time. From 1865 they were banned.

The south end of South Street, *c.* 1860. The large building is Lever & Co.'s coach works, and the capitals around the top read CARRIAGE MANUFACTURERS TO HRH PRINCE ALBERT. This interesting early Victorian building has since been demolished.

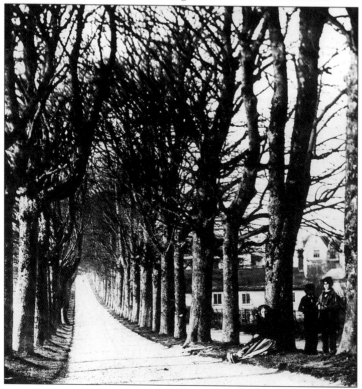

West Walks, *c.* 1860. The old Roman defences of Dorchester were made into tree-lined walks from the early eighteenth century. These promenades encircled the town, and were much admired.

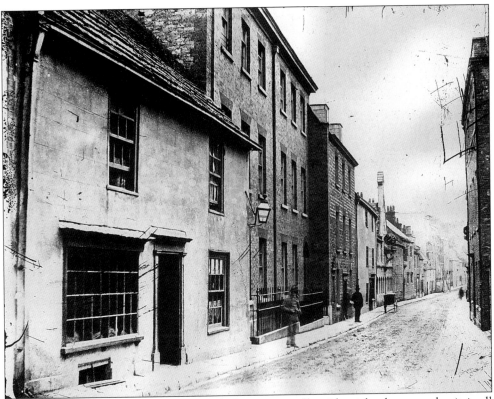

South Street, *c.* 1860. In the 1860s South Street was still residential, whereas today it is all shops. Almost all these Georgian houses have since been demolished.

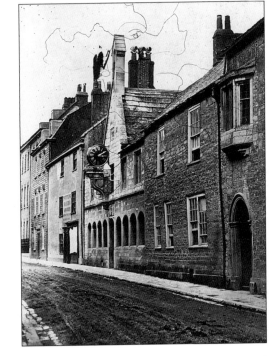

The Grammar School, South Street, *c.* 1860. The seventeenth century building in the foreground was replaced in 1883, but Napper's Mite, the arcaded part with the elaborate clock, survives today. John Hutchins, the eighteenth-century county historian, was one of the many educated here.

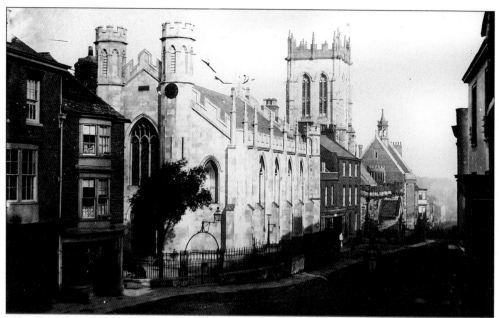

Holy Trinity Church, *c.* 1860. This early Gothic revival church only lasted fifty years. It was built in 1824 to replace the decayed original, and was itself replaced in 1875 by the present church. Mr Robert Davies, who ran the chemist shop opposite the church deposited contemporary coins in the walls when the church was rebuilt in 1824, and lived long enough to recover them in 1875. He died in his eighties in the room he was born in (1921 recollections of Dorchester). The three-storey Georgian house beyond the church was demolished in 1882 and the Dorset County Museum built on the site.

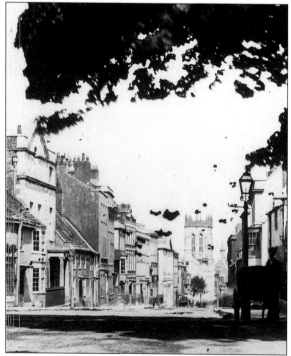

Looking down High West Street, *c.* 1860. The trees are part of the Walks. The mixture of low older houses and higher Georgian ones is still characteristic in the town.

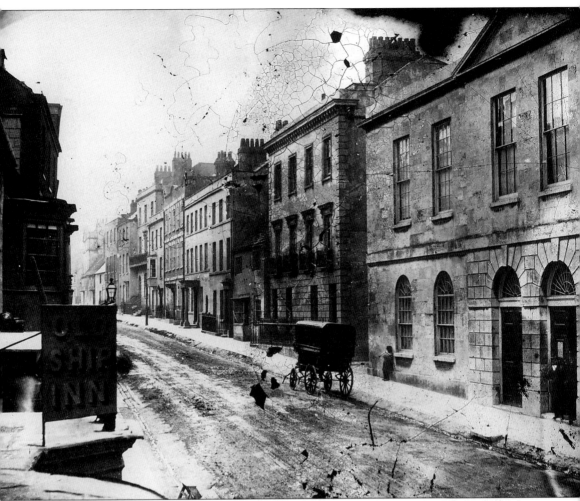

The north side of High West Street, c. 1860. The plain stone building in the foreground is Shire Hall, built in 1796-7. The further part housed the crown court, where the Tolpuddle Martyrs were tried only twenty-six years before this photographs was taken. Most of the buildings seen in the photograph still survive. 'The old-fashioned fronts of these houses, which had older than old-fashioned backs, rose sheer from the pavement' wrote Hardy in *The Mayor of Casterbridge*, and pedestrians had to dodge around bow windows and avoid 'door-steps, scrapers, cellar-hatches, church buttresses, and the overhanging angles of walls'. Due to the long exposures needed then, the 1860s photographs tend to make the town look completely empty: Hardy's novel fills it with the people.

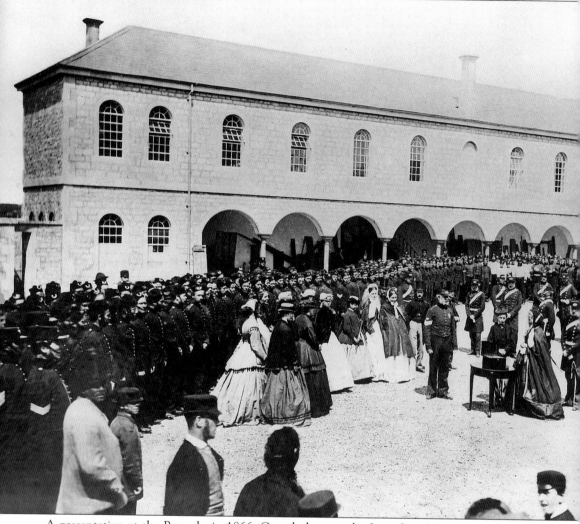

A presentation at the Barracks in 1866. Crowd photographs from the 1860s are rare because photography was still new and uncommon, and the long exposures meant that everyone had to stand very still or they were blurred. The Dorset Militia made a presentation to Mrs Bingham, wife of their commanding officer, to thank her for opening a reading room for them. The crinolines, hats and bonnets of Mrs Bingham and her friends contrast with the simple Militia uniforms. The building behind was the new Militia stores, finished only that year, and since demolished. William Barnes' poem of 1867, *The Do'set Militia* starts:

Hurrah! my lads, Vor Do'set men!

A-muster'd here in red agean

and makes much of Mrs Bingham's work for the men.

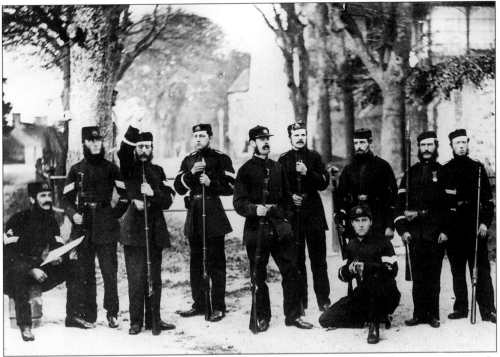

Dorsetshire Rifle Volunteers in 1863. Great improvements in the range and accuracy of the rifle in the mid-nineteenth century made it fashionable, and many counties established rifle volunteers as a supplement to the militia. Some of the Dorset Volunteers pose by the remnants of the Roman wall at Top o' Town, Dorchester. They were all Dorchester people; the only one identified is D. J. Godwin, standing sixth from the left.

A new house near the Railway Station, c. 1860. It is surprising to see a Victorian building looking so sparkling and new. The house was built for the station master, and was called South Western House because the railway was the London and South Western. The little thatched structure to the left is probably a picturesque garden shed.

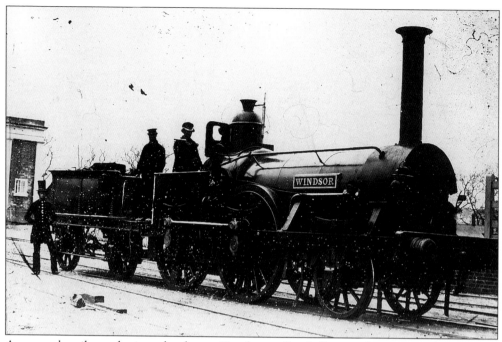

A rare early railway photograph taken at Dorchester South Station about 1860. The engine is probably no.40, *Windsor*, built in 1852. The driver stands in the open with no protection from the weather. Third class passengers were also unprotected. Dorchester South Station (just visible left) opened in 1847, as the terminus of the Southampton and Dorchester Railway.

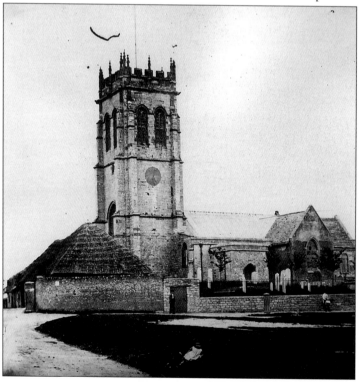

Fordington church, *c.* 1860. Fordington remained a proper agricultural village even though it was so close to the town of Dorchester. In *The Mayor of Casterbridge* Hardy wrote of it as Durnover, where the wheat ricks 'thrust their eaves against the village church; green thatched barns, with doorways as high as the gates of Solomon's Temple, opened directly upon the main thoroughfare'. The thatched roof to the left is one of those barns.

Two
The Later Victorian Town
1870-1900

'The Dorchester of today is a bright, trim town, which, so far as its four principal streets are concerned, can claim to be still picturesque. The ancient houses are being gradually replaced by new, while all around the grey old town are arising those florid suburbs which in days to come will make the present era famous for architectural ugliness'.

Highways and Byways in Dorset (1906) by Sir Frederick Treves.

Max Gate, the house Thomas Hardy built for himself on the Wareham Road, soon after it was completed in 1885. Treves was not referring to villas like Hardy's when he complained about the new suburbs, but to the smaller terraced and semi-detached houses built in their dozens after Fordington open fields were enclosed in 1874 and the areas adjacent to the old town could be developed.

Prince of Wales Road, *c.* 1890. This shows the ideal of late Victorian suburbs – a wide tree-lined road with good spaces between the large houses, and neat walls. The houses were built in the 1880s and still survive. They were not numbered, but named. The 1893 *Directory* lists Ingleside, Encombe, Elmfield, Belmont and Lydale Villa. The newly-planted trees were intended to give a rural finish to the development, which was inhabited by professional townspeople.

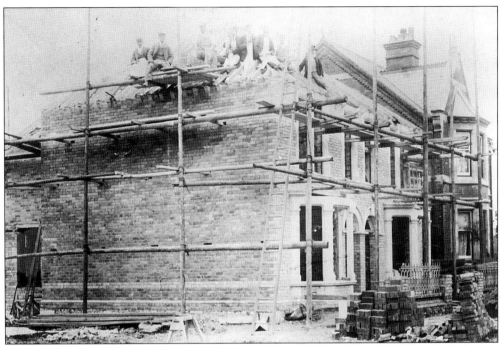

Monmouth Road, *c.* 1900. A very rare photograph of houses actually being built, with the men who built them shown in the bottom photograph. The houses are nos. 6 and 8 Monmouth Road, a pair of semi-detached houses. The builders all look very well-dressed for manual work, apart from the labourer with the hod for carrying bricks. There were nine building firms listed in Dorchester in the 1895 *Directory*: this is probably one of the smaller ones. The unnamed older man on the left was probably the owner of the firm.

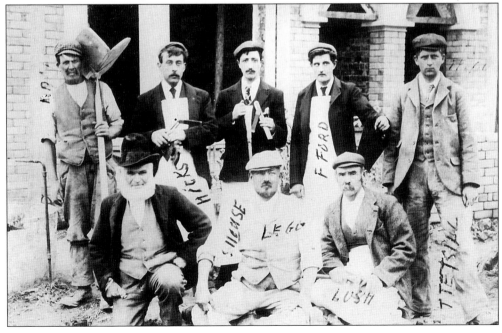

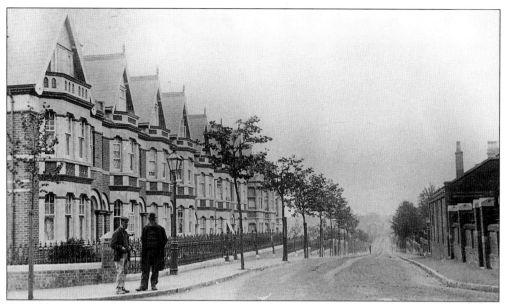

The top of Cornwall Road, *c.* 1900. The area was part of the Cornwall Estate, developed from 1876 with a dense concentration of terraced houses, which seem to have been constructed by several builders. These houses are all uniform externally, but all vary a little inside, suggesting that they were erected by different firms. The terrace is dated 1896.

St. Mary's Church, Dorchester.

St. Mary's Church, looking north to Top o' Town, *c.* 1900. The increasing population meant an increased need for churches, and St Mary's was built of corrugated iron in 1897 as a temporary measure: it was known locally as the tin tabernacle. The large church cost only £1,000 to build, and the site another £800. The interior was plastered and, with its traceried windows, it looked like an ordinary church from inside. The site was sold by public auction in 1912, and the present Baptist church constructed in its place.

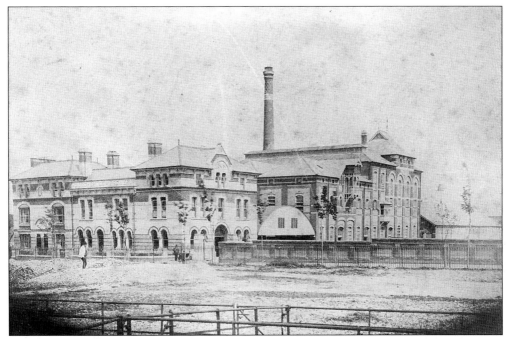

Eldridge Pope's brewery, c. 1880. There was much less industrial development than new housing, but the new brewery of 1880 was massive. It was built on a new site by the railway station in 1880 and railway sidings laid to run right along the front of the buildings on the right, so that barley and coal could be brought right to the brewery by train, and some of the beer sent out the same way.

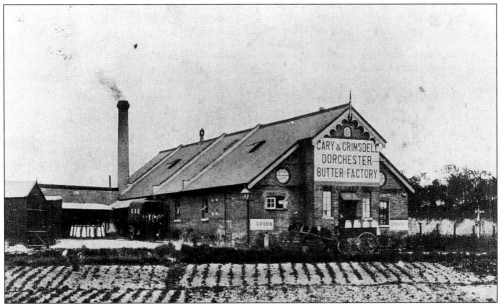

Cary & Crimsdell Butter Factory, c. 1909. A purpose-built factory constructed in 1887 as a candle works at a cost of £2,000. Candles were being superseded by gas – ironically the factory itself was lit by gas – and the candle manufacturers went into voluntary liquidation in 1893. It was taken over by the butter manufacturers. The building survives, much altered.

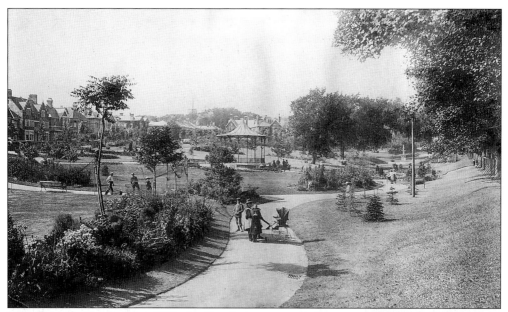

The Borough Gardens in 1898. As Dorchester expanded, it needed formal public gardens because the old recreation areas were being built over. The Borough Gardens were laid out in 1895: in this photograph the trees still look young and new, now they are mature.

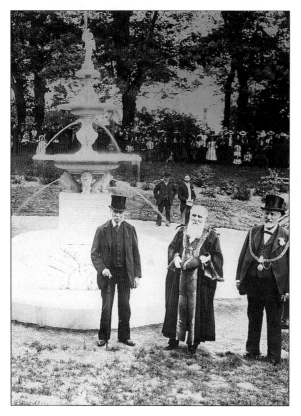

The unveiling of the Borough Gardens fountain, 1898. The bandstand (seen above) and the fountain were both added to the gardens in 1898. The bandstand cost just under £300, and was given by W.E. Brymer, the local MP. The cast iron supports were made in Glasgow. The stone fountain was given by Charles Hansford. After the official ceremonies were over the band of the Dorset Regiment played in the new bandstand, and at dusk 'the band played dance music and children young and old danced on the lawns. Then the fairy lamps were lighted, thousands of them having been arrayed at great labour' in the garden and West Walks. The 'myriads of twinkling coloured lamps' made the gardens like fairyland. (*Dorset County Chronicle*).

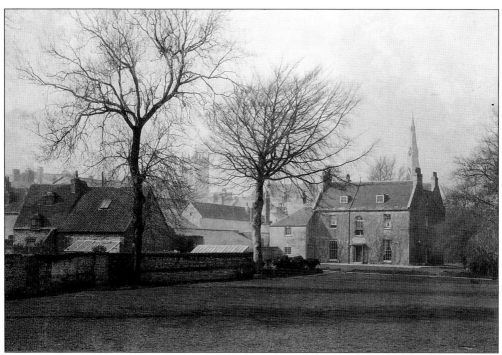

The grounds of Wollaston House, *c.* 1900. A few houses in Dorchester had large grounds, and one of the largest was Wollaston House, which before the development of Wollaston Road had eight acres of land. Even in the 1870s a cow was kept in the park-like grounds.

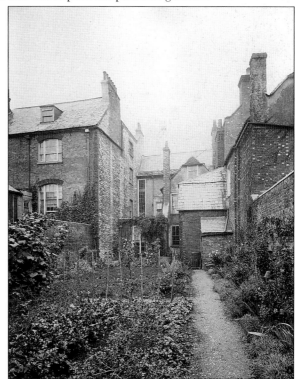

A garden at the back of South Street in the 1880s. The long narrow plot is more typical of town gardens, as is the collection of out-houses attached to the back of the house. The garden probably belonged to the Pouncey family, important photographers in Dorchester.

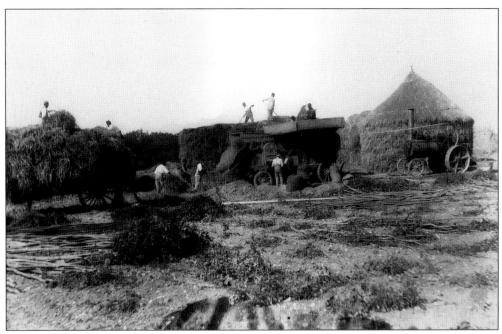

Two photographs of threshing in Fordington Fields, *c.* 1890. Only a tiny proportion of the farmland around Dorchester was developed, and farming continued on all the rest. The medieval open fields of Fordington were enclosed in 1874, and the land divided into farms. Here steam traction engines are used to power threshing machines. The wheat is taken from round stacks (right in the top photograph) and passed through the machine which beats the corn out and separates it from the straw. Steam traction engines and threshing machines were usually hired from a contractor, rather than being owned by a farmer.

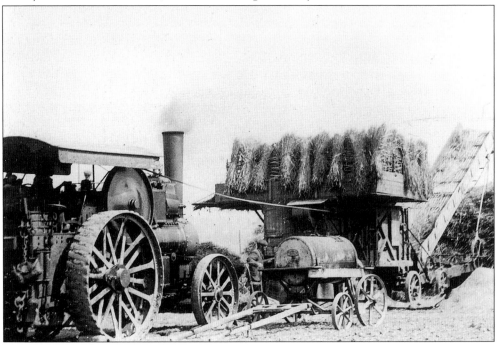

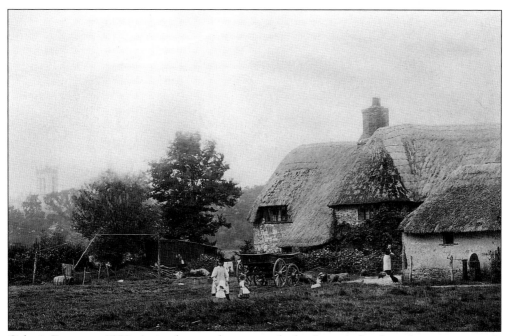

Coker's Frome, *c.* 1890. A timeless rural scene, with the farmer's family and a wagon outside their old farmhouse. As the tower of St Peter's church in the background indicates, this was very close to Dorchester, down in the water meadows. The house no longer exists.

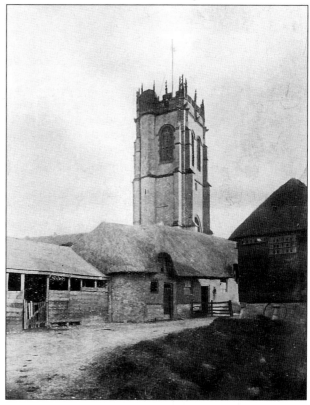

Fordington church, *c.* 1880. Fordington was changing from an agricultural village to a suburb of Dorchester in the 1870s. Revd Bartelot described Fordington as then evolving 'from semi-rural seclusion into suburban sunlight'. With the enclosure of Fordington Fields, new farmhouses were built outside the village, and those within it became redundant. This collection of cottages, barns (one with pigeon nest boxes) and sheds were demolished in the 1890s to make way for a redbrick vicarage.

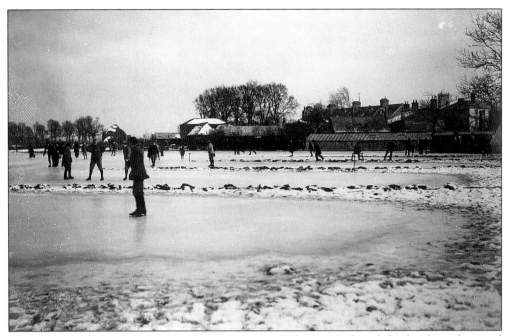

Skating on East Meadow, Fordington in 1895. Miss Fisher remembered this hard weather, and that the meadows were deliberately flooded for skating. Sometimes farmers charged entrance fees, and employed a band to entertain the skaters.

Looking down Fordington High Street, *c.* 1900. A contrast with the opposite photograph, as this end of the High Street was full of old houses. The hill was lowered to ease the gradient in 1839, and many Roman burials were found, some of them cremations in pots.

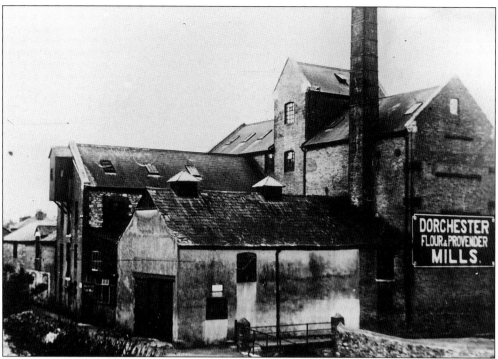

Dorchester Flour Mills, Fordington, in the late 1890s. The mill at Fordington was rebuilt on a much larger scale in 1891, producing the large building seen here. The tall chimney was needed because the new mill was powered by steam, rather than water-power from the river. Many labour-saving machines were included, and the grain did not have to be touched by hand from when it was put in the silos until it appeared as flour. The corn was 'rollered' into flour, instead of being ground by stones. The miller admitted that the flour produced was more granular, but assured customers that they would get used to it.

Looking up Fordington High Street, c. 1900. In contrast with the photograph on the opposite page, this part of the High Street has much Victorian development, with early Victorian villas first, and then later terraces.

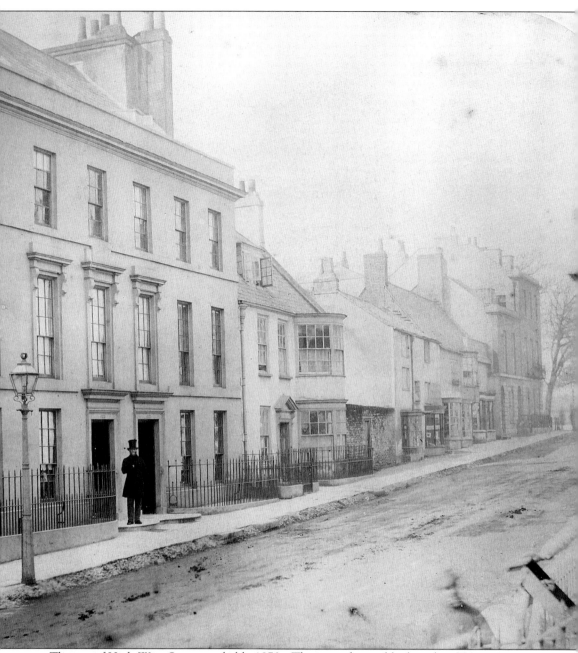

The top of High West Street, probably 1870s. This area changed little in late Victorian times. The gentleman in the top hat stands in front of two mid-nineteenth century houses which still survive, as does the bow-fronted house next door. The two big houses were occupied mid-century by Charles Parsons who owned the soda-water manufactory in Trinity Street, and John Randolph Tooze, a solicitor (1921 recollections). The low shops further up the street were demolished around 1900, and higher buildings constructed. The railings to the big houses have recently been replaced: they were taken for salvage in the Second World War.

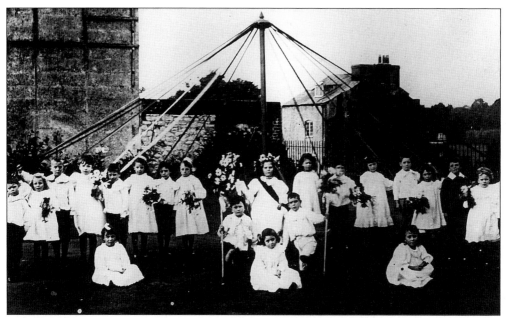

The May Queen at West Fordington in 1895. It looks like a proper surviving local celebration but in fact it was part of an entertainment given by the Congregational Band of Hope, the children's branch of the Temperance movement which was opposed to all alcohol. The May Queen (centre) was Minnie Gundry. In defiance of tradition, boys were included and alternate in the photograph with the girls. The complicated dance movements needed to braid the ribbons around the may pole were entrusted to girls alone.

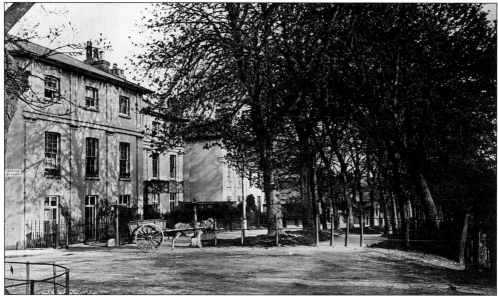

Looking down West Walks in the 1890s. Railings were a necessity before cars took over; fences and rails kept horses and animals out of gardens, but also all transport had to be tied up, or a small boy paid to hold the horse. The small two-wheeled cart is drawn by a donkey who is tied to the railings. The imposing villas were built about 1830, on what was then the very edge of Dorchester.

31

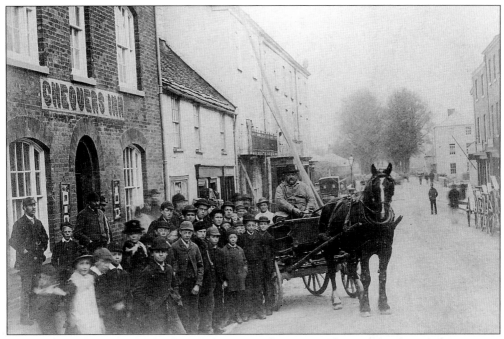

Outside the Chequers Inn, High East Street, in the 1890s. The man in the one-horse gig is attended by a crowd of children, with men behind who may be the customers of the inn. Perhaps he was the landlord. His trap looks only large enough for one.

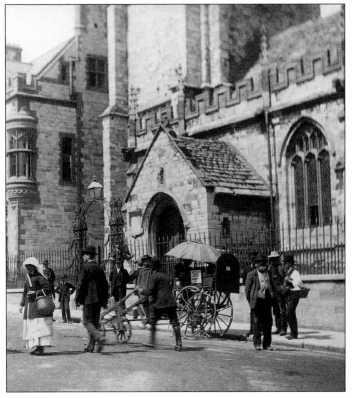

Outside St Peter's Church, c. 1900. The wheeled devices here were powered by people. In the foreground is a heavy pair of sack trucks, used for moving all sorts of goods. Behind it with bigger wheels is a knife-grinding machine, which appears to have three wheels because a penny-farthing bicycle is leant against it.

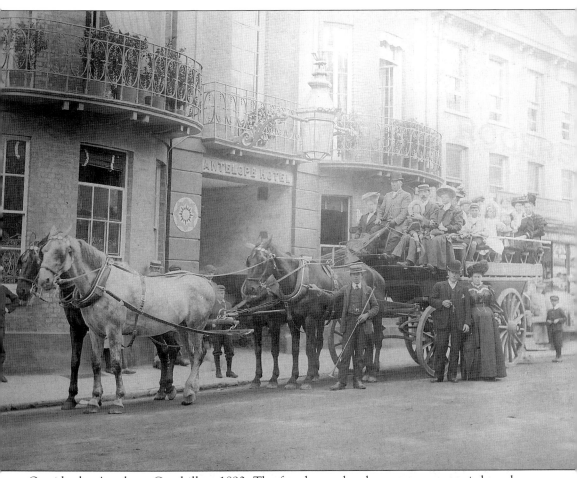

Outside the Antelope, Cornhill, c. 1890. The four horse charabanc or wagonette is huge by contrast with the trap opposite. The man beside the horse carries a simple horn, like those used earlier to warn that the stage coach was coming. The Antelope had been a coaching inn, but by 1890 those days were long past. The wagonette is probably just off on an excursion since many of the passengers are children. The bus which ran to the Antelope from the station would have been a covered vehicle. T.C. Newman remembered the Antelope in the late nineteeth century, with its 'cosy bar parlour which each evening formed a sort of informal club room for so many of the local citizens, and the stable yard [with] ostlers busily engaged, some washing down carriages, some polishing up harness, others grooming horses, all such activities having a sort of musical accompaniment, that curious sound, half whistle, half hiss, which any work connected with horses seemed always to evoke'.

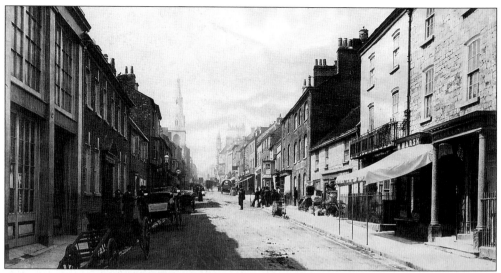

High East Street in the 1880s. The many shops in the street generate lots of traffic; carts, hand-carts and so on are parked along the sides. One shop on the right has much of its stock on the pavement. The building on the left was Stroud & Co.'s coach works, a very plain and sophisticated workshop and showroom of the 1880s. A little higher up on the same side Crocker and Son at The Cooperage were making baskets, malt shovels, corn measures and all sorts of useful wooden objects. A surprisingly rural manufacture which seems to belong to an earlier age.

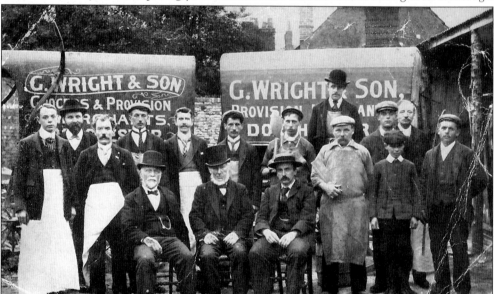

Gideon Wright (centre front) provision merchant, with his staff and transport, 1890s. His shop was at No.19 High East Street from 1870. At Christmas 1897 he was advertising 'A Large Stock of Selected Goods' and stating that their aim was 'to work their business on sound principles, not arranging to sell anything below cost as is frequently done to arrest attention, but buying all goods at lowest price and selling at lowest possible prices' as they had done for forty years. They were getting back at the first chain grocers, International Stores, which had recently opened the first chain-store shop in South Street, and was advertising in 1897 'save twenty per cent' by dealing with them. The war between local and national grocers was just beginning.

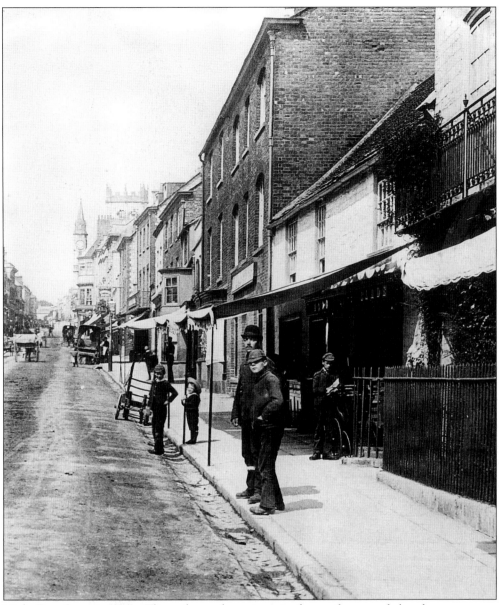

High East Street, 1890s. The poles and awnings in front of some of the shops are very decorative. High East Street then had most of the important shops – it has declined recently.

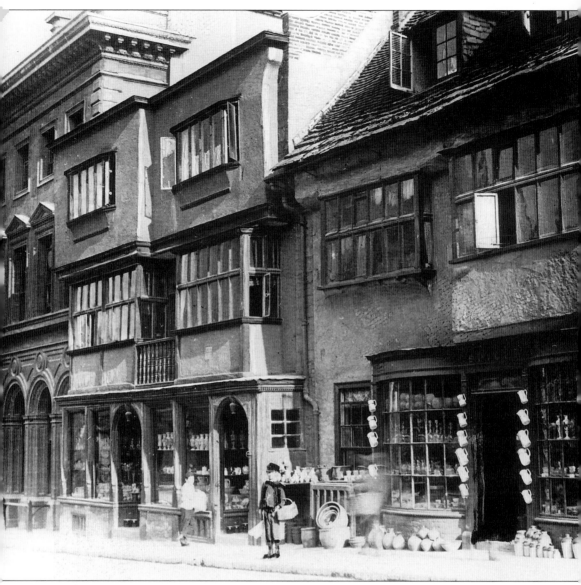

High West Street, probably 1880s. James Spicer's China and Glass Warehouse filled the two shops shown here. To the right of the door are stoneware bottles and jars, and to the left Verwood earthenwares from the kilns of east Dorset. The big bowls are bread bins, and there are also jugs, owls and bowls. The rest of his huge stock is refined white wares from Staffordshire. The houses are early seventeenth century, but the one on the right had shallow shop windows added in the early nineteenth century. The other is Judge Jeffery's lodgings. Few seventeenth century buildings survived the many fires Dorchester suffered in the seventeenth and eighteenth century. When thatch was common in towns fires spread fast. The fire of 1613 was bad, and was followed by smaller ones in 1622, 1713, 1723 and 1775.

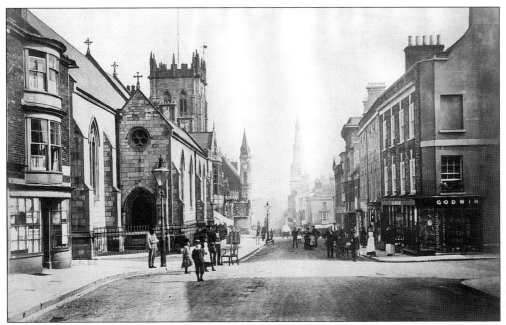

High West Street about 1890. Holy Trinity church was again rebuilt in 1875 (see p14), in a plain and simple style. The clock tower (centre) was added to the town hall in 1864. The 1890s town centre is much the same as it is today. Most of the rebuilding took place between 1860 and 1890.

A Dorchester family, 1880s. Thought to be the Feacy family, possibly in their own home rather than the photographer's studio. The children are in the best clothes, but their mother looks to be in black, possibly mourning.

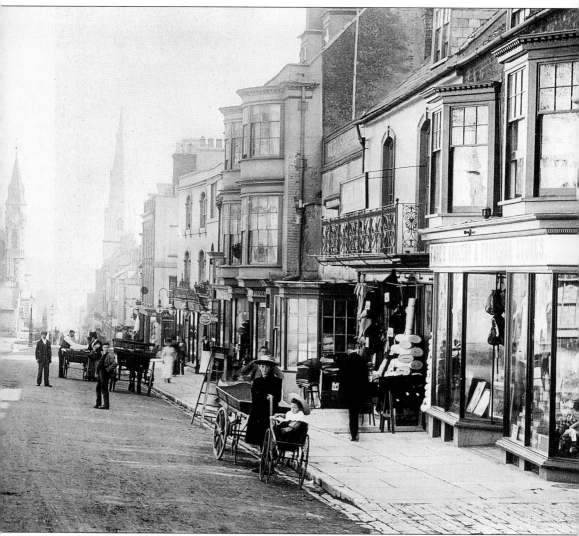

High West Street in the late 1890s. The first shop on the right was M. Marsh, draper, with bales of fabric outside. Next is the Old Ship Inn, with a big bay window. The tall bay windows mark Mrs Hazel's ironmonger's shop, and beyond that are Miles & Son, saddlers, and Pitfield's hairdressers with one of the employees at the door in a long white apron. A good urban mixture. The pram in the foreground has only one handle, like a miniature Bath chair. In the 1893 *Directory* Charles Joliffe was still advertising as a Wheel Chairman - 'Bath Chairs with Rubber Tyres'. He was the successor to the sedan chair of the eighteenth and early nineteenth century which was carried by two men. Mr Joliffe pulled his customers. Behind the pram is a hand cart.

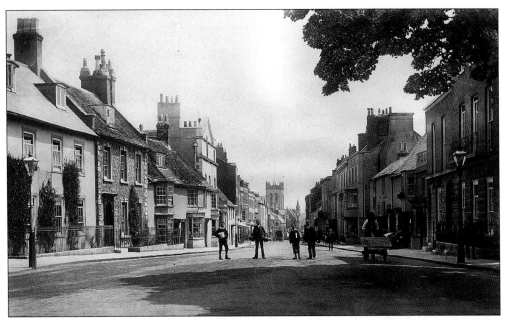

Looking down High West Street in the 1880s. This picturesque view down the main street, partly framed by the trees on the walk was a favourite with photographers.

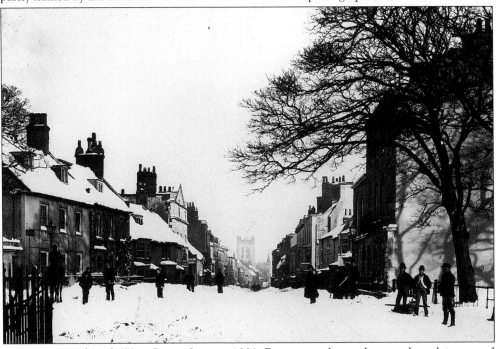

A snow-covered High West Street, January 1881. Every time the roads were cleared, it snowed again in the night. The town had no newspapers for three days, and few trains ran. One night the mail train to London only got as far as West Stafford before it got stuck in drifts and had to be pulled out by another train. It returned to Dorchester. A bullock worth forty guineas (£42) froze to death in a train stuck between Dorchester and Maiden Newton. The distress was so bad that a soup kitchen was set up to feed the poor.

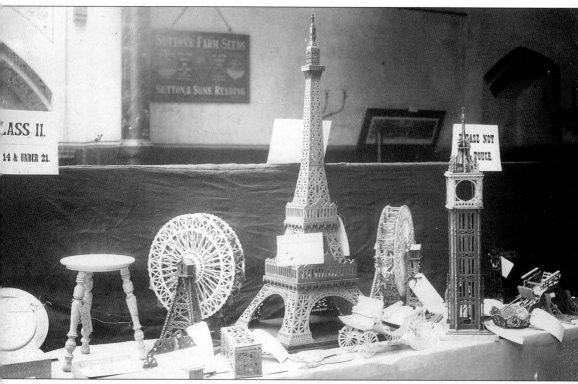

The Spare Time Exhibition, 1896. These wonderfully intricate fret-work models seem typically Victorian to us. They were displayed in the Corn Exchange. The Under-21 class (left) includes rather more useful objects.

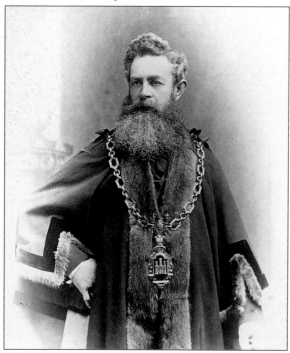

William Tilley, Mayor of Dorchester between 1891-2. He was head of a firm of builders and monumental masons with premises in Princes Street. A member of the County Council, and father of several children including Mathew Tilley (see p46) and T.H. Tilley who was the producer for the Hardy Players.

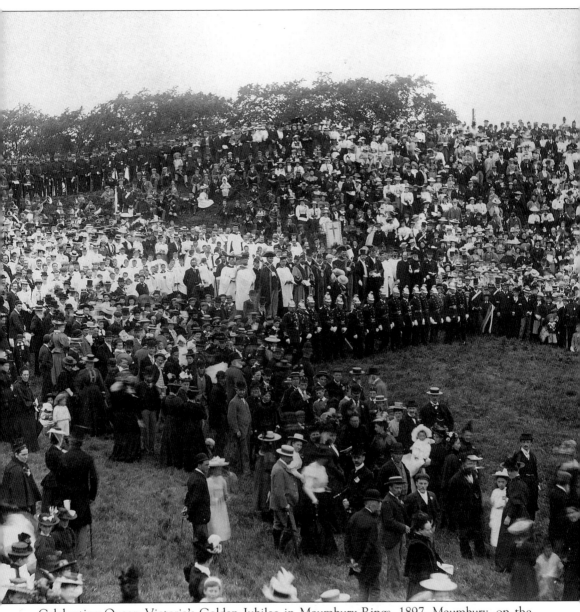

Celebrating Queen Victoria's Golden Jubilee in Maumbury Rings, 1897. Maumbury, on the edge of the town is a useful old earthwork. Having been a Roman amphitheatre, its shape is perfect for big meetings and displays. Here the Borough Fire Brigade are drawn up in a line in front of the platform which holds the mayor and other dignitaries, and behind them are the Vocal Association and the church choirs. On the very rim of the earthwork are the Volunteers, the local part-time soldiers. Loyal speeches were made, hymns sung, and at the end the Volunteers fired a rapid chain of single reports from their guns. After the Old People's dinner in the Corn Exchange some of the guests were a little elated, and danced in the street. Worse followed; an ill-advised hogshead of free beer in Salisbury Field led to men, women and children 'to be seen in a state of intoxication, and several of them lay extended on the ground hopelessly drunk'. *The Dorset County Chronicle* solemnly pointed out that the celebration committee were not responsible for this 'scene of disgraceful excess'.

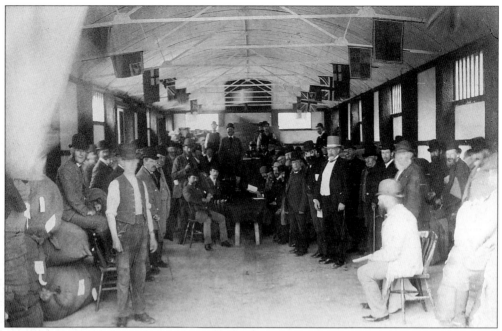

An auction sale of wool, 1892. These sales began in the 1880s, and continued annually in July until 1939. The 1892 sale was in Duke's hide and skin market building by the western station. 200,000 fleeces were sold in 1892, at prices ranging from 9d to $11\frac{3}{4}$ per lb. (See p65)

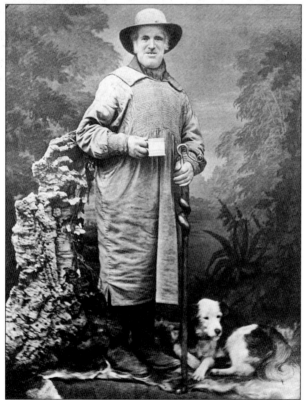

A Dorset shepherd, in the 1890s. He looks very natural with his crook, mug and dog, even though posed in a photographer's studio with a painted backdrop. The traditional smock was becoming less common in the 1890s, which is probably why the photographer picked him out. Shepherds and their sheep were a common sight in Dorchester because the farming on the chalk downlands around the town was based on sheep.

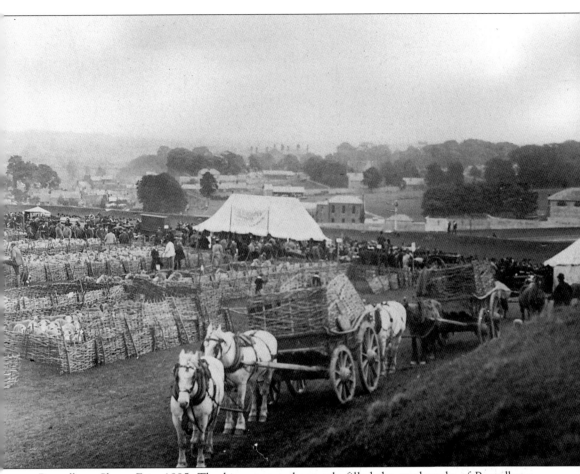

Poundbury Sheep Fair, 1895. The big autumn sheep sale filled the earthworks of Poundbury Iron Age Hillfort. 1895 was only a small fair, reported the *Dorset County Chronicle* because the scorching weather meant farmers were worried about feeding livestock on parched pastures. Sheep sold for between 48s (£2.40) and 61s (£3.05), not good prices. Sheep farming in England was becoming less profitable because of competition from Australian wool. The town had had open access to Poundbury from time out of mind, but in 1876 the Duchy of Cornwall, who owned all the land in Fordington, enclosed Poundbury with iron fences and gated it off. *The Dorset County Chronicle* complained 'The ground is a famous place for football, cricket, and other amusements, and as such has been exceedingly well appreciated by the inhabitants'. The Revd H. Everett of Holy Trinity led the protest against enclosure, and the Duchy gave way, admitting that the public had the right to use Poundbury 'for purposes of recreation on foot, but not on horseback, without payment'.

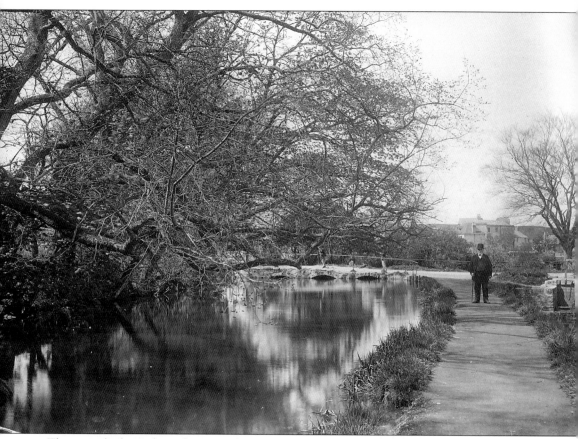

The river, looking along the riverside path towards John's Pond and the Grove, *c.* 1900. The Victorian buildings at the bottom of the Grove can be seen behind the figure. The picturesque path survives, but is much more grown in with trees. The River Frome was still an important source of power in 1900. Fordington Mill had converted to steam (see p29), but West Mills, Friary Mill and Loud's Mill were still all water-powered. The water here, above the town, was probably reasonably clean, but from just below the town, at Loud's Mill it was full of sewage. Four thousand pounds were spent on building the first sewers in Dorchester in the 1850s, but they simply collected the material and poured it into the river. Ironically, when a sewage farm was finally built in 1899 there were numerous complaints about the awful smells it produced. Obviously the river had been a better option.

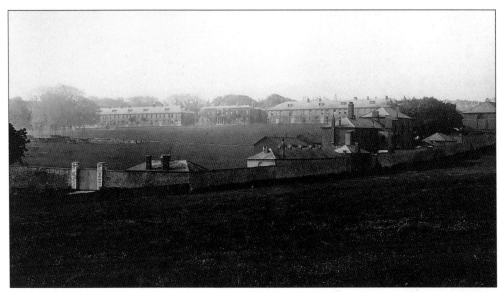

The barracks, *c.* 1900. Dorchester was an important military base from the 1790s, when the barracks seen here were constructed. The Parade Ground runs down the hill in front. These are the Marabout Barracks, much less prominent than the Victorian Depot Barracks off Bridport Road (see p70).

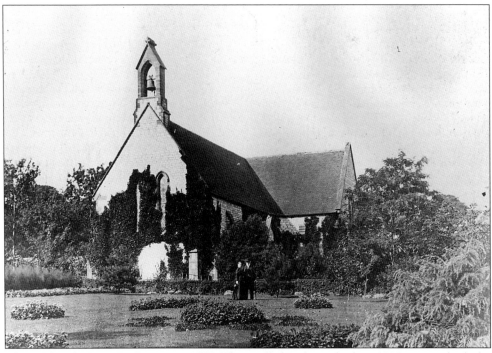

Christ Church, West Fordington, *c.* 1870. The small church was built in 1843 to serve both the barracks and the growing population on the west side of Dorchester. It was demolished in the 1930s. The Revd W.C. Osborne lived at the vicarage nearby, and is accompanied by his daughter in this photograph. He died in 1880.

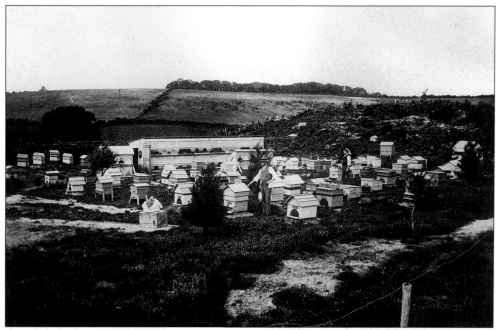

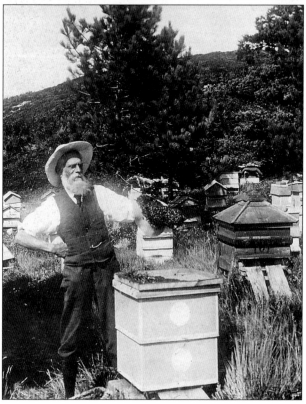

Frome Whitfield, c. 1900. Over the river to the north of Dorchester, Frome Whitfield was a separate parish in medieval times, but declined to a hamlet by the seventeenth century. Both these photographs show Mathew Tilley (a son of William Tilley, see p40) with his bee farm at Frome Whitfield. He was a watch and clock maker with a shop in South Street. By 1905 he had added jewellery to his stock, and was advertising the shop as 'One of the sights of Dorchester' with 'A grand stock including one thousand watches of every description, one thousand clocks and timepieces, one thousand gold and gem-set rings'.

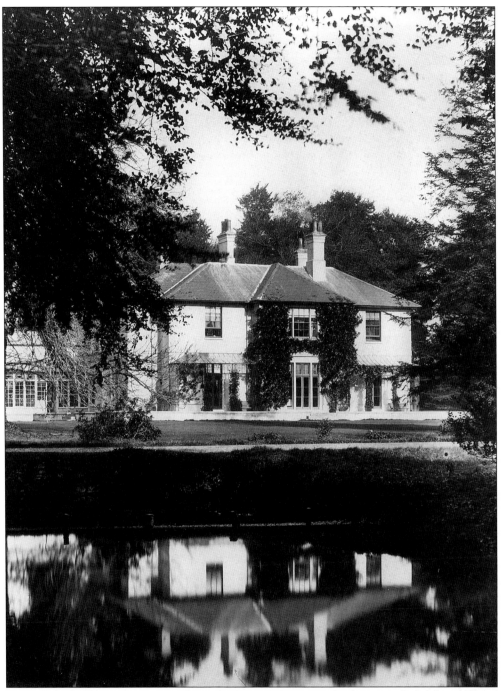

Frome Whitfield House, *c.* 1900. The early nineteenth century big house replaced the medieval village. In 1895 Lieutenant-General Shurlock Henning lived there. The house is less than a mile from Dorchester, but very secluded. Now, as then, it sits concealed by trees right down in the river valley.

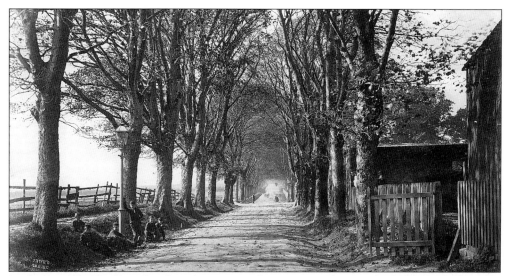

Looking up the Bridport Road in the 1870s. The avenues of trees which lined all the roads leading into Dorchester were almost as famous as the Walks. The Avenues had been planted in the 1770s, but most have now gone. These trees were felled after the First World War, long after the road was lined with terraced houses (see p70).

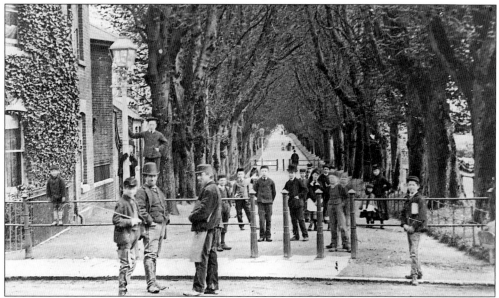

Along South Walks, *c.* 1900. South Walks is (and was) lined with chestnut trees, and is one of the most impressive parts of the Walks. In the nineteenth century a keeper of the Walks was employed by the Borough. He swept the paths and was supposed to stop children climbing the trees. Since he was usually old and the Walks are extensive, the children evaded him easily. Before breakfast in the 1890s a visitor to the Walks would have been surprised by the three Misses Case exercising. Miss Fisher remembered them as 'elegant looking women with a modern outlook. They considered exercise essential to an enforced sedentary life [they ran the bookshop and stationers in Cornhill]. Walking was not enough, running undignified without an object, so bought enormous wooden hoops and bowled them through the Walks before breakfast'.

48

Three
Edwardian Summer 1901-1914

'Where is the Dorchester of my early recollections? … Of the shops as I first recall them not a single owner remains. Only in two or three instances does even the name remain …

Dorchester's future will not be like its past – we may be sure of that. Like all other provincial towns, it will loose its individuality – has lost much of it already. We have become a London suburb, owing to quick locomotion'.

Thomas Hardy in 1910, on being given the Freedom of the Borough of Dorchester,
comparing 1910 with the Dorchester of the 1850s and '60s.

Bowling Alley Walk, *c.* 1913. Despite Hardy's pessimism, it still seems to retain its character.

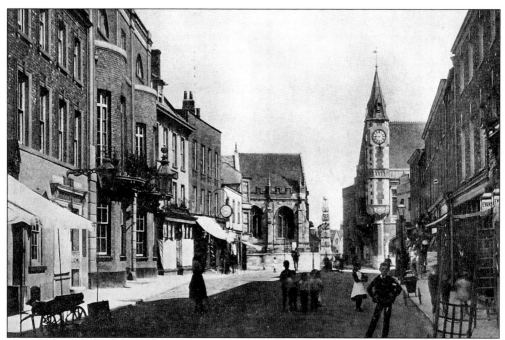

Cornhill in 1906. The very centre of town, with a mixture of shops, houses and the Antelope Inn. Cornhill remained important, even though shops were spreading into other parts of town.

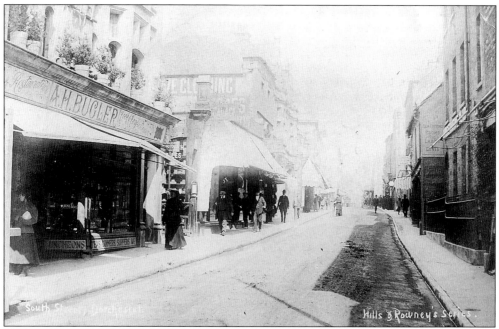

South Street, c. 1905. Houses remain on the right, but shops have appeared all along the left hand side of the street. Buglers were advertising in 1905 'Family Bread and Biscuit makers' and they also produced Dorset Knobs. 'Wedding and Birthday Cakes a Speciality: Muffins and Crumpets in Winter Season: Ices to Order'.

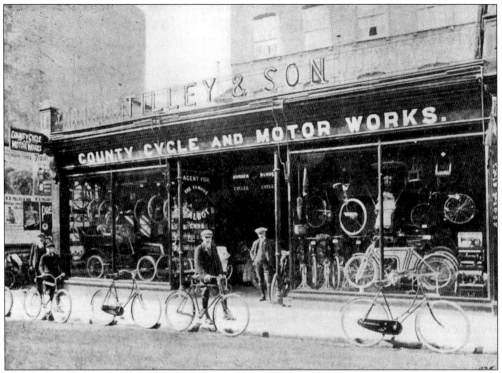

Tilley's Cycle and Motor Works, No.45 South Street, *c.* 1906. Tilley's cycle shop was established about 1893, when cycling was expanding. Penny-farthing bicycles were only suitable for the young and strong, but the invention of the modern bicycle in the 1880s and the pneumatic tyre (with air in) in the 1890s opened up cycling to anyone who could afford a machine. In 1911 Tilley's were advertising 'a sound-build bicycle (the Dorset) at £3-17s-6d (£3.87½) – better value cannot be obtained anywhere'. Tilley's possibly made these bicycles; they certainly produced 'Tilley's Patent Cycle Holder', a simple stand to hold a parked bicycle upright. In the left hand window is an early car. The huge sheets of plate glass forming Tilley's windows were admired by several Edwardian Guides to the town. The *Dorset County Chronicle* recorded the building of the shop in 1895 'in front of his private house and adjoining his silversmith's shop'. The shop was set back from the street to allow for road widening. Miss Fisher remembered women 'being taught to ride [the bicycle] by Tilley. They paid 1/- [5p] an hour for hire of cycle and lesson. Poor Mr Tilley would struggle along holding these rather unathletic ladies up while they nearly fell on top of him. They were dressed in shirts with stiff collars and leg-of-mutton sleeves and long skirts. The lessons generally took place in South Walks and were a sight not to be missed'.

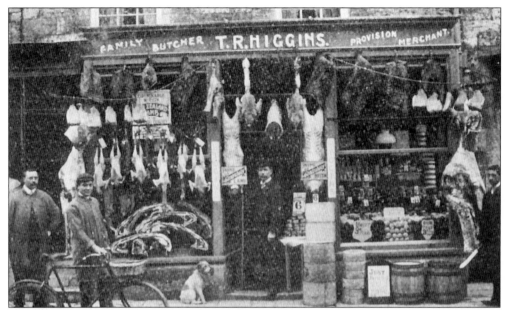

Higgins's butcher shop, No.51 High East Street, *c.* 1906. Edwardian advertisements played many tricks on the customer. Accompanying this photograph is text which pretends to be part of the book, but which was clearly written by the butcher himself. 'We strongly recommend him for both quality and price. His reputation is widely known. If you deal with Higgins you can start a savings bank book at once. He is the Noted Public Meat Caterer in the Market on Saturdays'. The delivery bike was up-to-the-minute transport for town deliveries.

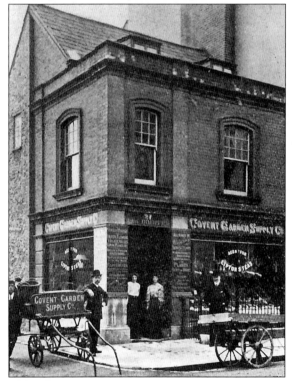

The Covent Garden Supply Co., No.27 High East Street, *c.* 1906. They were fruiterers (English and foreign), greengrocers and florists, selling Dutch bulbs as well as flowers. Oddly they were also the agents for Lipton's teas and coffees.

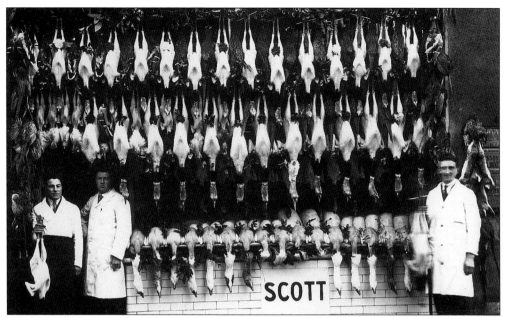

Scott's, fish, game and poultry dealer, No.18 South Street, *c.* 1910. Their shop was next to Napper's Mite. Mr Bailey stands on the left.

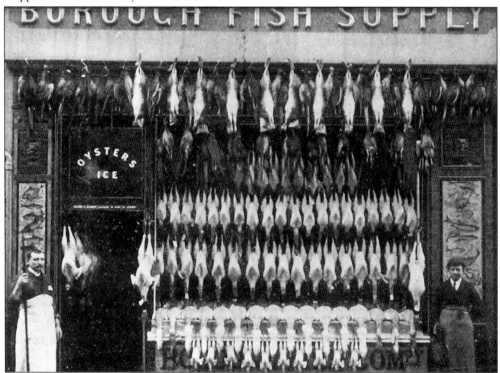

The Borough Fish Supply, No.3 South Street, *c.* 1906. They also supplied oysters. The unhygenic-looking displays of poultry probably mean that both photographs were taken at Christmas. There was a third fish and poultry shop in Dorchester, the County Fish Supply in High East Street.

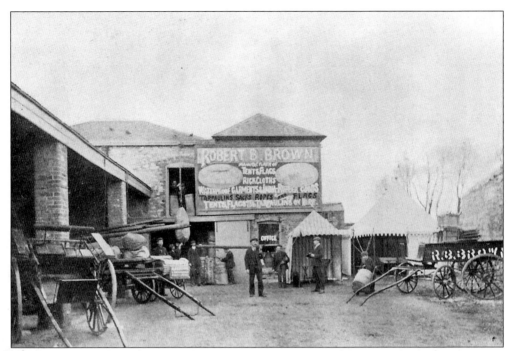

Robert Brown's Tent Works, London Road, c. 1906. Browns were established in the 1880s, and opened the London Road works in the 1890s. They manufactured marquees, tents, rick cloths, sacks, ropes, waterproof garments, carriage aprons, motor garments and aprons, portmanteaus, trunks and bags in 1906, besides hiring out tents, marquees (seen set up here), flags and awnings.

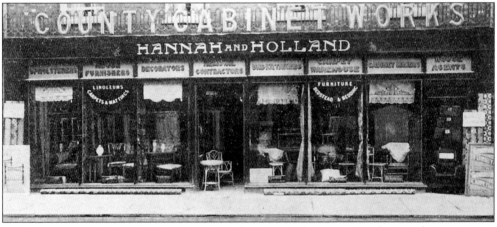

Hannah & Holland, County Cabinet Works, Cornhill, 1906. Besides supplying carpets, furniture and storage, the firm were undertakers, valuers, house-selling agents, cabinet makers, decorators, upholsterers and removers. The firm continued supplying many of these services (as Shepherd & Hedger) until the 1980s.

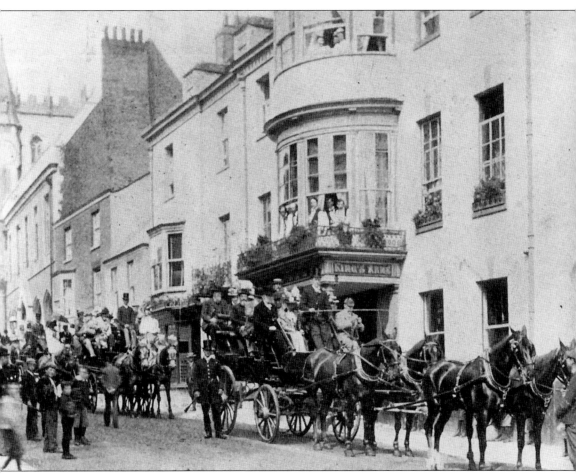

The King's Arms, from an advertisement of 1906. The charabanc is loaded ready for a trip, and has a coachman in top hat and a uniform which was old-fashioned even then. Another man in similar uniform standing by the vehicle holds a coach horn, and on the carriage following behind is another uniformed man, seated high on the box. This may be one of the excursions run from the King's Arms using the *Tally-ho* coach (possibly the back vehicle). From the 1890s some of the coaches which had languished in store for fifty years (since the railways took over long-distance transport) were wheeled out again for 'heritage' pleasure trips. The King's Arms ran novelty excursions to Woodbury Fair in 1894-5, some of the passengers travelling in a charabanc, but led by the *Tally-ho* coach heralded by its traditional horn. Summer trips for tourists were also run in the old coaches, but charabancs were much more common.

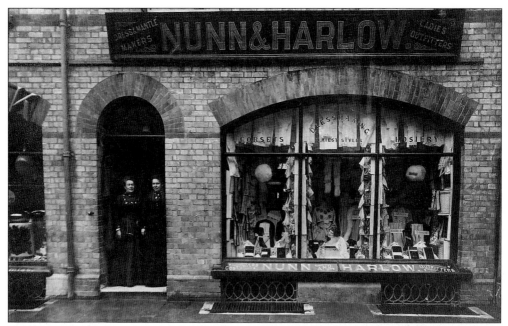

Nunn and Harlow's, costumiers and outfitters shop, No.52a South Street, 1903-7. The firm (probably consisting mostly of the two women seen in the doorway) only lasted for about ten years, and sold cloth, clothes (including cycling knickers – presumably bloomers), underclothes and gloves, as well as making clothes. People in the middle classes and above had their clothes made for them: ready-to-wear, off the peg clothes were virtually unknown until Edwardian times, and were uncommon even then.

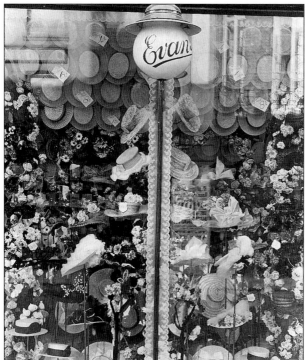

Evans Drapery Bazaar, Cornhill, c. 1900. The window is full of hats, and decorated with artificial flowers. Everyone wore a hat outdoors until the 1930s, so shops selling them were also common.

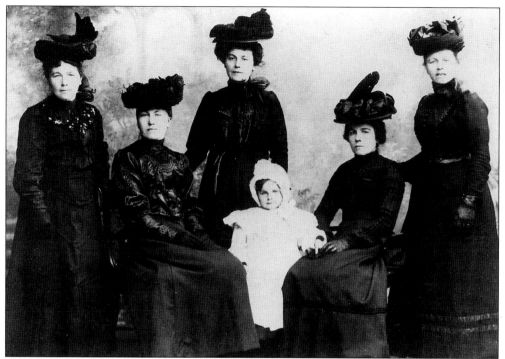

Five sisters from Fordington, *c.* 1906. All are in black mourning, apart from the little girl. The hats are splendid, elaborate confections, clearly best hats. From left to right: Mrs Grubb, Mrs Thomas, Mrs Meare, Mrs Meader (and daughter Joan) and Mrs Staples. The photograph is thought to have been taken after their father's death.

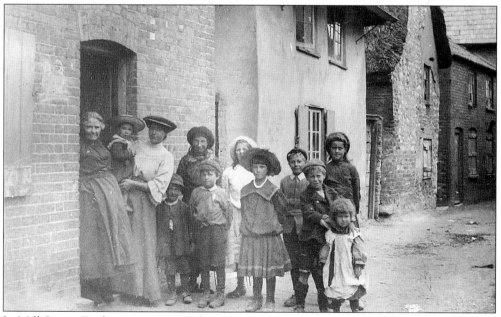

In Mill Street, Fordington, *c.* 1900. The only people without hats are the little boy (right) and the woman standing in her own doorway. Even with everyday clothes, and in the poorest area, hats are to be worn.

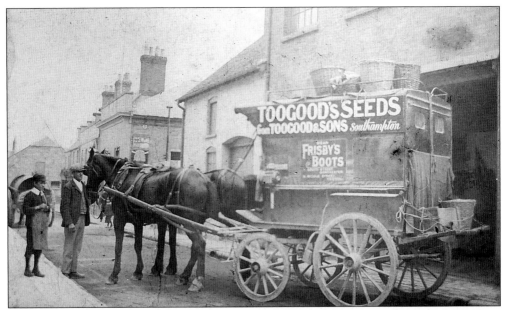

Carrier's van in Princes Street, *c.* 1901. Mr Pitcher, who owned this van was the carrier from Litton Cheney to Dorchester, coming to the town on Wednesdays and Saturdays. Carriers were the main means of communication from the villages, taking both passengers and goods. In 1903 nearly fifty carriers came to Dorchester: bigger and closer places like Cerne had services four days a week, but most were only on Wednesdays and Saturdays for the markets.

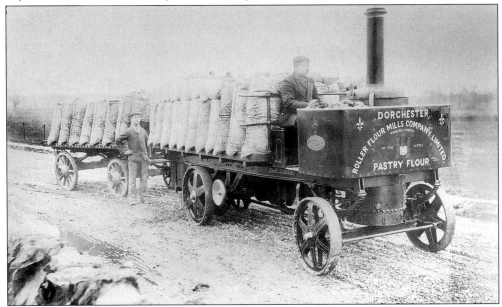

Foden Steam lorry and trailer loaded with sacks of flour, *c.* 1910. The lorry belonged to the mill at Fordington, seen on p29. Steam lorries were the first real lorries; steam traction engines had sometimes been used to haul loads on trailers, but vehicles like this one were the first to have the engine attached to the load-bearing part, like a modern lorry. This one was made by E.S. Hindley & Sons of Bourton, North Dorset. All traction engine drivers (and many steam-lorry drivers) had to stand but in this one you sat.

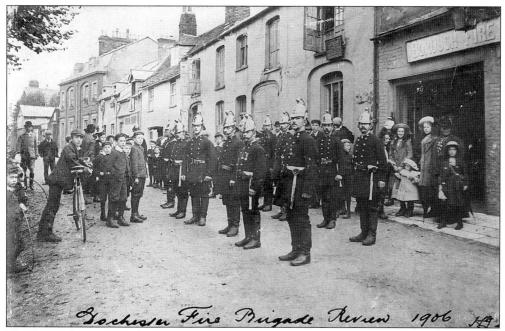

The Borough Fire Brigade in Princes Street, 1906. The men are lined up ready for review, accompanied by boys one side and girls the other. Their headquarters can be seen on the right. They attended fires within the Borough for free, but charged outside it.

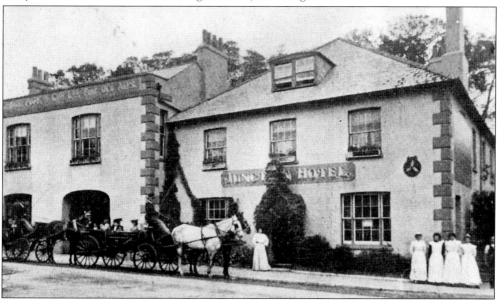

The Junction Hotel from an advertisement of 1906. When railways were the most important form of travel, the Junction was very well placed because all traffic from both the stations passed the hotel before reaching the town centre. In 1906 they were advertising horses for hire for hunting, extensive stabling, post horses and carriages for hire, and brakes (also called charabancs – like the first vehicle) for large parties. On Wednesdays and Saturdays there was a market dinner for those attending the market nearby. The staff, four maids and a man (right) don't seem enough to cope with all this.

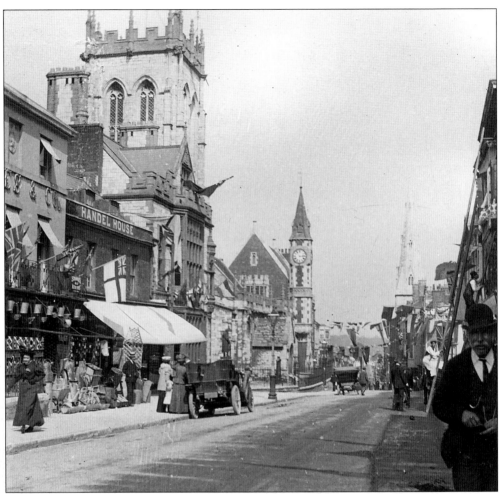

Looking down High West Street, probably 1911. The flags suggest a coronation celebration, and it is probably 1911, the coronation of George V. All the shops were decorated, many displaying pictures of the King and Queen. In the competition for decorations, Fare's Grocery Stores won with 'a display of palms, ferns, and other plants, and a handsome arrangement of draperies in yellow and green .. with a framed portrait of the King, flanked by GR.. while lines of pennons spread right and left from a flagstaff'. *Dorset County Chronicle*

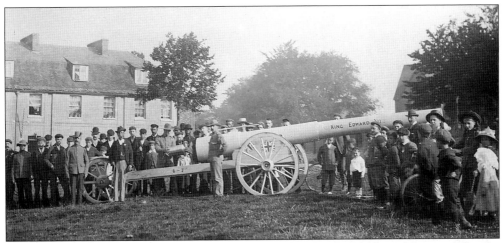

On Fordington Green, 1902. The huge gun paraded as part of the celebrations for the coronation of Edward VII in 1902 does look a little heavy for its carriage; in fact it was a fake. The *Dorset County Chronicle* reported that it caused quite a stir, and had been 'fabricated in Fordington by Mr George Harris, tin and coppersmith and Mr Frank Norman, baker'. The paper thought it large enough for a battleship (18ft long). The makers were assisted 'by a team of "gunners" and "drivers", attired in khaki uniforms and Imperial hats ... and as they drew it through the streets they fired salutes at intervals'. The man standing in front of the gun is in the 'uniform' and hat.

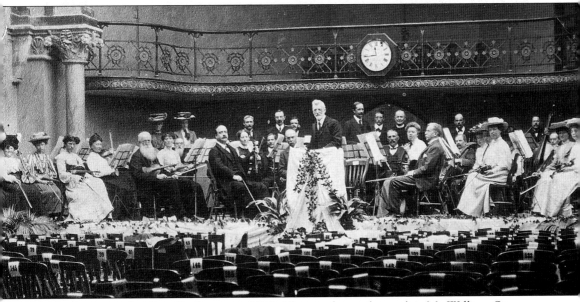

An orchestra in the Corn Exchange, *c.* 1910. The conductor (centre) is Mr William Stone, director of the Weymouth Choral Society, who was usually the first violin in the Dorchester Madrigal and Orchestral Society orchestra. Their usual conductor was Edgar A. Lane, who had founded the society in 1902. In 1909 *The Dorset County Chronicle* reprimanded the people at Dorchester who 'take but a languid interest in the cause of music', judging by the tiny audience at the Corn Exchange for the Dorchester Society's annual concert. A professional soprano from London had been engaged, and she sang the Jewel Song from Gounod's *Faust* along with lighter drawing room ballads. The programme included orchestral and choral pieces as well.

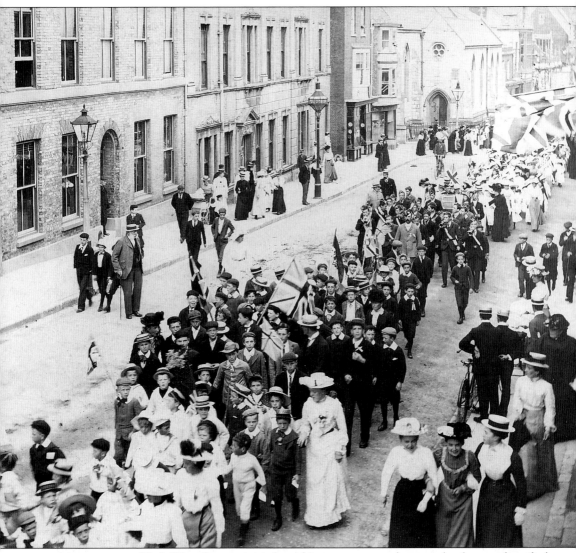

A procession in High West Street. An informal, very summery photograph of an unidentified celebration in Edwardian Dorchester. It is not the 1897 Jubilee or the 1902 or 1911 coronations because the houses are not decorated. Groups of children march with their leaders and flags, and in the middle is the Boy's Brigade band with their bugles. The people in the procession out-number the spectators. Perhaps this is a Whit Monday Sunday schools parade?

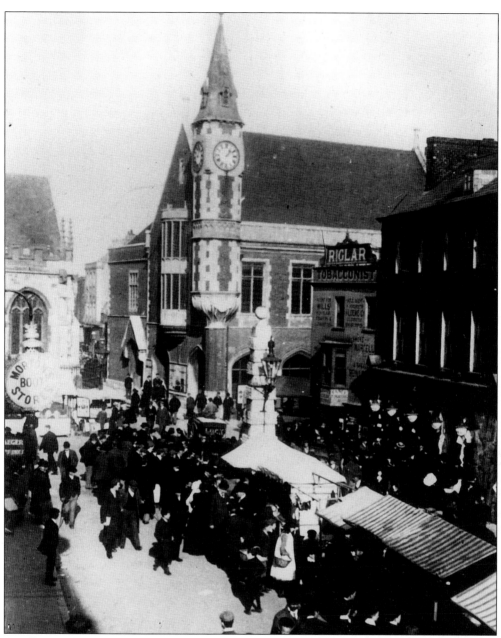

Candlemass Fair, Cornhill, 1910. The street is wide here to accommodate fairs and markets. *The Daily Chronicle* described this fair on 14 February 1910, contrasting the modern fair with its 'rows of canvas booths and stalls for the sale of gingerbreads and lollipops, toys and trinkets, and other fairings' with the old hiring fair of sixty years earlier (described by Hardy in *Far from the Madding Crowd*) when rows of labourers lined the streets looking for a place. The newspaper compared the old fair to a slave market. Even in 1910, although there was not a smock to be seen, 'some old-fashioned farmers, and equally old-fashioned labourers, still prefer to "agree" in the old-fashioned way'. Large entries of grazing cattle and stock bulls were found at the serious part of the fair, and at another auction milch beasts, barreners (all cows) and sheep were sold. The top price for a heifer and calf was £23 15s.

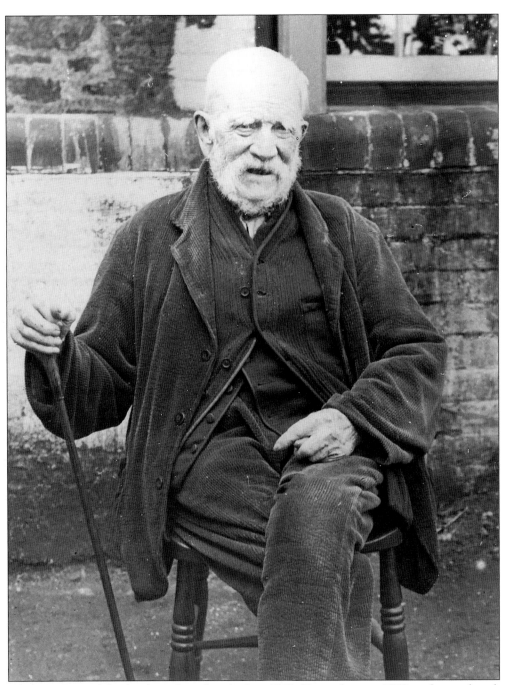

Job Green, retired shepherd, aged one hundred, in 1910. He was born in 1809, and started work as a shepherd's boy when he was seven. He was living in the Dorchester Workhouse in 1910, when he was interviewed by a newspaper, and was asked (apparently at the request of 'certain London papers') if he'd observed any great changes in the 'Hardy' Country. He replied "Eh, What? 'Hardy Country'. Wur's that then? I've a-lived in Dorset". On being pressed as to whether he had heard of Hardy, Job asked "What di 'er doo?", but even with the clue of 'writing books' he declared "Never yeard o'en. Thomas Legg I do know".

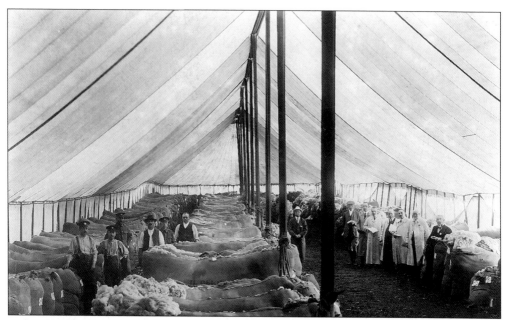

Duke's Wool Sale, *c.* 1914. Soldiers (left) help to move the great bales of wool. Sample bales are open so that they can be inspected, and smaller lots can be seen on the right. The bales were placed on wattle hurdles to keep them off the damp ground. See p42 for an earlier sale.

Part of a sheep-shearing match, June 1912. The match was organised by the South Dorset Agricultural Manual Instruction Committee, and held in the Repository Yard at the end of Charles Street just off South Walks. *The Dorset County Chronicle* reported: 'In the bright June sunshine, with fresh greensod and hurdlepens as the scene, the shearing was a pretty sight, the shearers wholly intent on their work, in their Oxfordshire shirting and trousers of drab jean, moleskin or corderoy' (jeans in Dorchester in 1912).

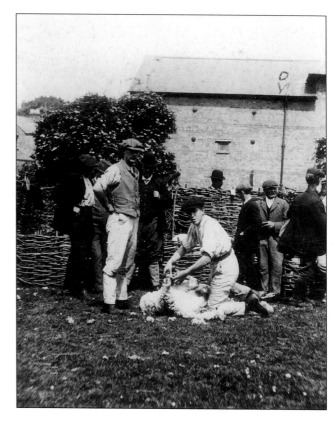

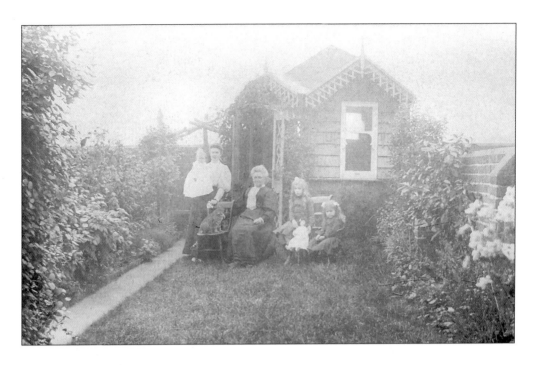

Two views of No.12 St Helen's Road. The top photograph shows the back garden sometime around 1910. The bottom photograph shows the front of the house at a slightly later date. St Helen's Road was built in the 1890s, and this house had a decorative porch/greenhouse added a little later. The view of the back garden is an unusual one; only rarely were small gardens photographed. The wooden shed is incredibly elaborate for its size. Mr and Mrs Charles Lacey lived in this house from about 1908 to the 1930s. Charles Lacey owned the *Dorset County Chronicle* and the *Southern Times* newspapers from 1913, having been a partner and employee earlier. When he died in 1931 at the age of eighty-eight he had been working at the same newspaper office since 1854 with only one break of six months. Mr Lacey had been at the British School in Dorchester with Thomas Hardy, and wrote his memories of the novelist just before he died. Until a year before his death he worked at the *Chronicle* office for two or three hours before breakfast, returned home for that meal, and then went back to work until eight or nine at night. A fifteen hour day was usual with him. In his younger days he joined the Rifle Volunteers, and must be amongst those on p17. The people in the top photograph must be Mrs Lacey with their only daughter and three grandchildren.

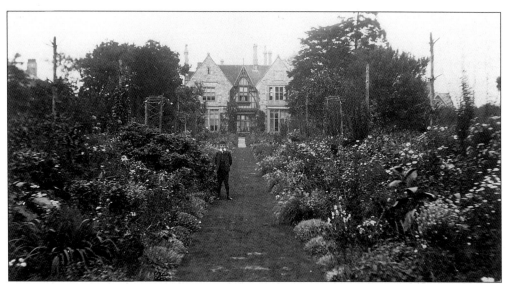

The gardens of Holy Trinity Rectory, c. 1900. The gardens of the Rectory (now absorbed into the old hospital site) were large and well-tended. In 1904 the Gardener's Society of Dorchester visited 'at the kind invitation of the Revd Canon Rowland and Mrs Hill' to see 'the long sloping walk, carpeted with soft resistant turf, and edged with deep borders filled with herbaceous plants ... growers of herbaceous plants often came from far afield to see the display'. The Gardener's Society consisted of local head gardeners, not people who did their own gardening.

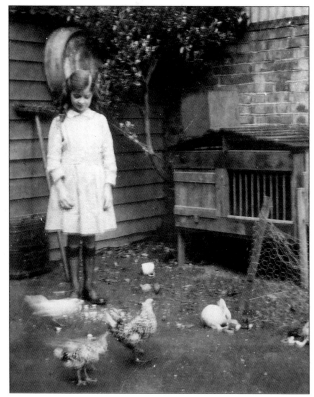

Kathleen Vidler with her pet bantams at the back of No.29 Icen Way, perhaps in 1916. The Icen Way backyard was only visited by friends.

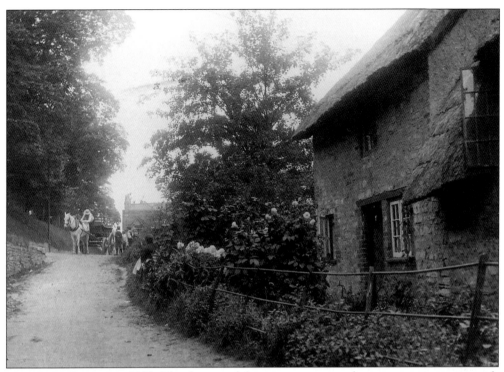

Hangman's Cottage, c. 1909. The density of the town centre on the next page contrasts with the old outskirts shown here. New suburbs were growing on the south and west of the town, but other parts remained unchanged and very rural. Hangman's cottage is only 300 yards from the High Street, but the thatched cottage and farm wagon look miles from a town.

St George's Road, Fordington, c. 1900. St George's Road is on the outskirts of Fordington, and here looks like a remote village. The cottage in the foreground survives, but not this roadside part of the thatched cottage. The first house was the Red Cow Dairy. It now adjoins suburban housing.

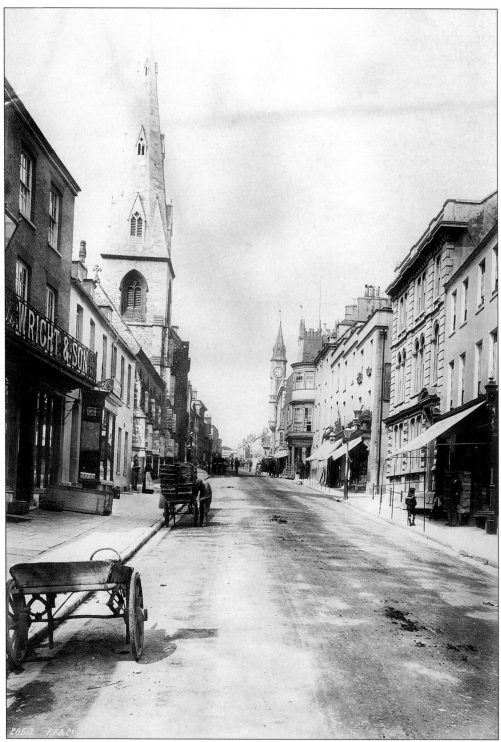

Looking up High East Street, *c.* 1900.

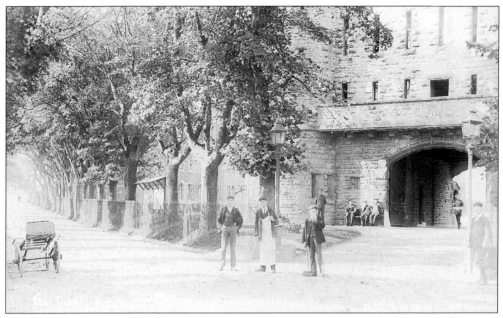

The Depot Barracks, *c.* 1913. Dorchester was a military town, having had barracks (see p45) from the late eighteenth century. The Depot Barracks, at Top o' Town, are Victorian, with the big stone keep (right) built in 1879 as a powder magazine and store for 2,500 stand of arms. The avenue of trees lining Bridport Road was felled soon after the photograph was taken.

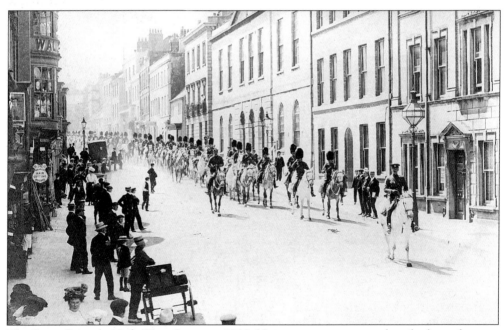

The Scots Greys in High West Street, *c.* 1900. Visiting troops quartered at the barracks were much appreciated for their bands. Miss Fisher, who lived just by the Barracks, remembered the contrast of the funeral march they played all the way to Fordington graveyard when there was a military funeral, and the lively topical tune played on the way back.

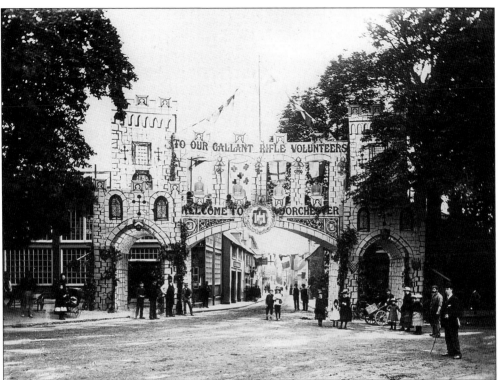

Two different welcoming arches erected at the south end of South Street, c. 1901. When most people arrived in Dorchester by train, this was the main entrance to the town. The Rifle Volunteers (see p17) fought in the Boer War in South Africa alongside the Yeomanry and the regular soldiers. All the Rifle Volunteers would have been from Dorchester and the immediate area, which accounts for the size of the arch. The smaller one was probably for part of the Dorset Regiment, as they distinguished themselves at both Botha's Pass and Alleman's Neck (mis-spelt on the arch). Triumphal arches were quite often erected in late Victorian and Edwardian times. Besides military victories, they celebrated the occasions when the Bath and West Show came to Dorchester.

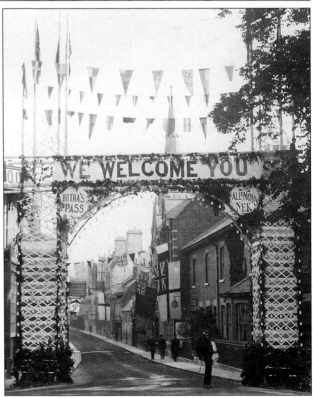

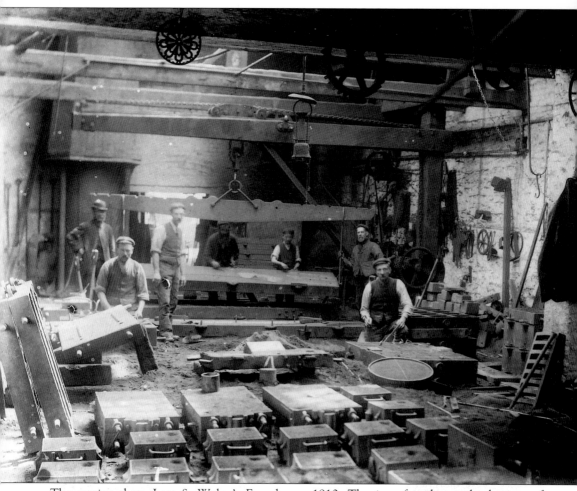

The casting shop, Lott & Walne's Foundry, *c.* 1910. The iron foundry at the bottom of Fordington High Street was established about 1830 and from the early twentieth century (as Lott & Walne) was well-known for its high quality farming implements, water carts and pumping machinery. The works bell, rung for the start of work, lunch and finishing time, was Fordington's time-keeper, and if it was forgotten the whole community was put out. In the casting shop wooden frames (foreground) were filled with fine-grained sand. A wooden former in the shape of the article needed was pressed into the sand, and then removed leaving a void of the right shape. Molten iron was then poured into the void. There was also a large blacksmiths' shop, to make the parts which had to be of wrought iron, and the firm also cast brass. The pattern shop produced the wooden formers needed for casting, and presumably also the wooden parts like the steps for the shepherd's hut opposite. The foundry continued casting until 1967, although the range of its products became smaller because of competition from larger manufacturers.

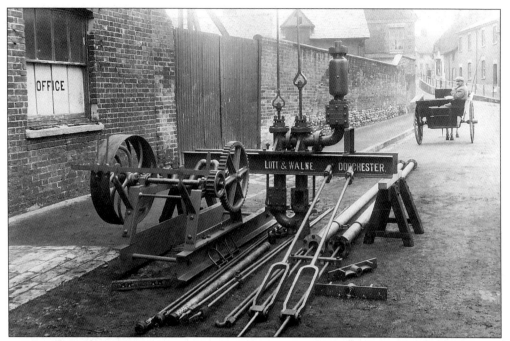

Machinery outside Lott & Walne's, *c.* 1910. Fordington High Street is to the right. The rods, pumps and other equipment were used for pulling water from a well. Lott & Walne provided a complete service for water supplies including a water diviner to locate the water, sinking the well and installing their own pumps.

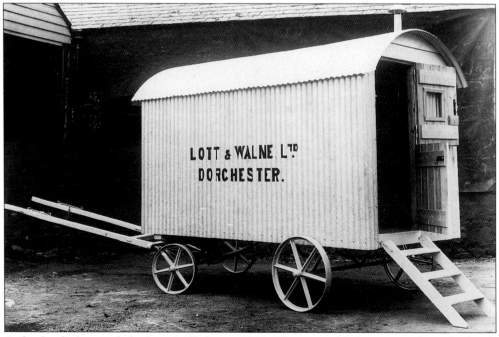

A shepherd's hut made by Lott & Walne, *c.* 1910. These portable huts were where shepherds lived at lambing time so as to be with their flock day and night. Gabriel Oak nearly died in his in *Far from the Madding Crowd*.

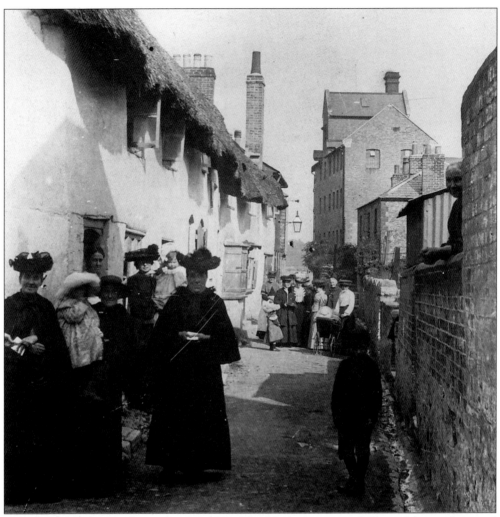

Mill Street, Fordington between 1900-1910. The black mourning clothes, elaborate hats and the child dressed in white are very like those on p57, but not identical. Fordington Mill is in the right background. Mill Street was at the centre of the poorest area of Fordington, and was the only part not owned by the Duchy of Cornwall. Since the Duchy would not release land for building, more and more houses and people were crammed into Mill Street. The Revd Henry Moule described Mill Street in 1852 as the worst part of his parish, with about one hundred and twenty houses and a population of about six hundred. 'The privies, if not directly over the mill-pond, are carried into the water. I think only one of the one hundred and twenty cottages has a privy attached to it for the exclusive use of its inmates. As many as eighty, and even one hundred, individuals frequent one'. Inevitably, Mill Street was at the centre of many epidemics, including the bad cholera outbreak of 1854 when thirty people died in Fordington, half of them from Mill Street. Mr Fisher, the Dorchester doctor in the late nineteenth century, told an old Fordington couple that the wife's bad leg should be amputated. Her husband refused, saying 'If the Lord be pleased to take 'er let 'n take 'er, but it's not for E to have one leg first and she to folly on with t'other'. Little had changed by the early twentieth century when these photographs were taken, except that the families look much better fed than they would have done in the 1850s. The houses were still old and crowded, and the poorest of the area lived here. Every family seems to have many sturdy children.

74

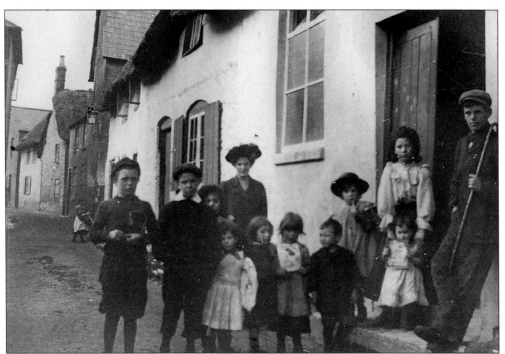

Two views of Mill Street,
Fordington, 1900-1910. The first
cottage (with the big window) in
the top photograph became the
Mill Street Mission in 1905 (it is
seen in the photograph on the
right before conversion). In 1931
the Mission set up the Mill Street
Housing Society, dedicated to
demolishing these slum cottages
and building modern houses and
flats which could be let at low
rents. Florence Hardy, the
novelist's widow, was chairman of
the Society, and did much work to
help raise money for the new
homes.

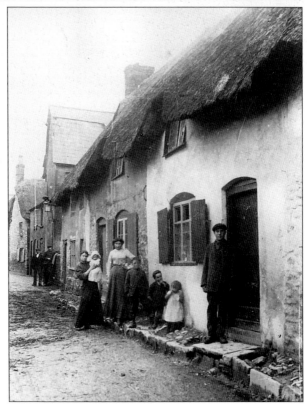

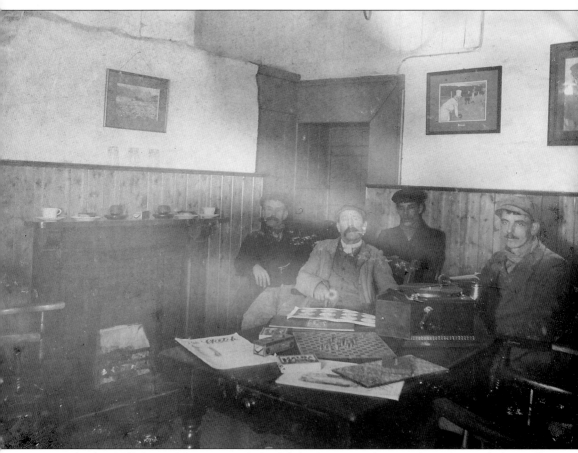

Inside the Mill Street Mission, *c.* 1912. While St Mary's (opposite) represented the High Church, Mill Street Mission was very low. It was founded in 1905, was interdenominational and dedicated to improving conditions in Fordington. The reading room (seen above) was the ground floor of one of the thatched cottages seen on p75. The same room was used for services, meetings and so on. The ceiling and floor to the upper storey was removed to make the room more spacious. Fordington men have games and newspapers to lure them away from the public house.

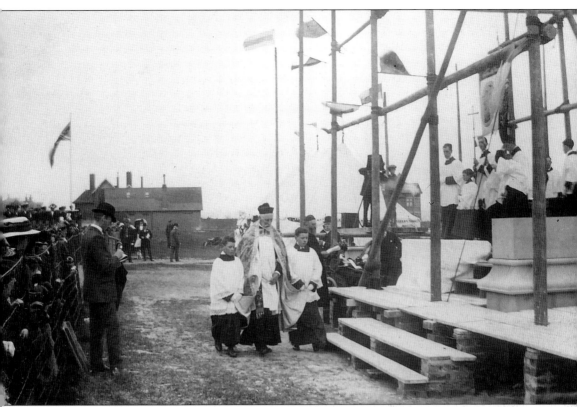

Part of the ceremonial procession at the laying of the foundation stone for the new St Mary's church, 1910. A great contrast to the Mill Street Mission, with Canon Collard and Geoffrey and Ronald Lane (probably servers) in festive (and High Church) clothing. They were preceded by a censer, dispensing incense, and supported by twelve other clergy. The rest of the procession was dominated by freemasons, two hundred and twenty of them. *The Dorset County Chronicle* was 'not a little impressed by the "trappings and the suits" of the Masons and the number and nature of the mystical emblems and symbols borne along with gravity in solemn state'. The head of the procession was the Tylers of the Dorchester and Weymouth lodges, carrying drawn swords. 'The builder, Mr Hoskings, a Mason in both senses of the word, carried the plan .. and was followed by the handsome golden vessels containing the emblematic elements'. Dorchester had never seen anything like it. Canon Collard had built the tin church at Top o' Town (see p22) and so had the extremely rare distinction of having built two churches in one parish. St Mary's replaced the tin church.

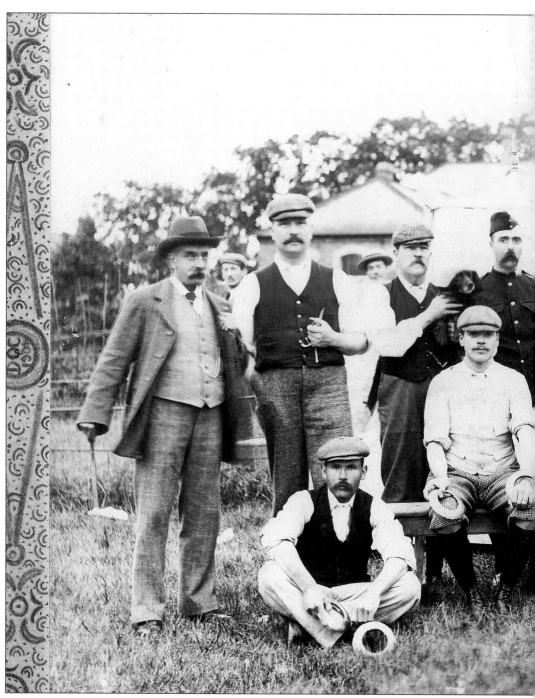

The Sydney Arms Quoit Club, 1904. A photograph taken in the field at the back of the steam laundry, Bridport Road, close to the Sydney Arms. It must have been very hot for the players to have removed their jackets. All retain their waistcoats, exposing braces to public view was not decent. All have moustaches, and all have hats. Quoits involved throwing rings (which they are all holding) over a peg. The initials in the hand-drawn borders are DQC, suggesting Dorchester Quoits Club rather than the Sydney Arms, but one or the other may be a joke. Quoits were very

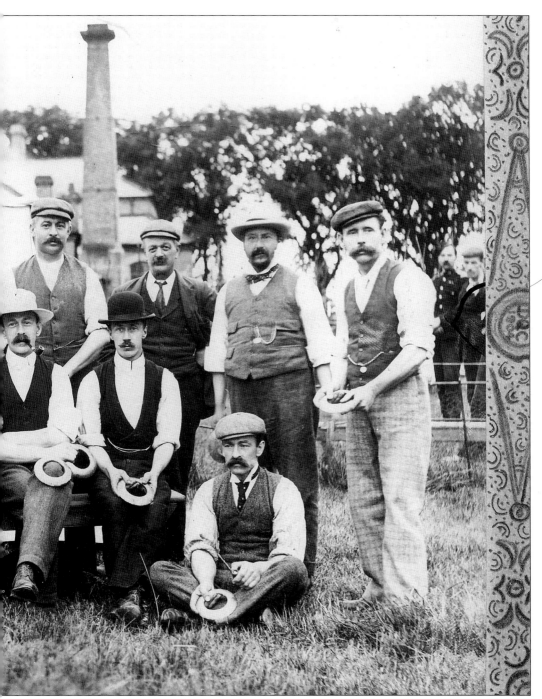

fashionable in Edwardian Dorset, and in the summer of 1904 the *Dorset County Chronicle* reported several matches including one between three champions – G. White of Wareham, John Daw of Puddletown and J. Mears of Cerne with 6lb quoits on a pitch of eighteen yards, with stakes at £2 a game. Dorchester had pitches at Victoria Park, Wareham House (now the Trumpet Major) and presumably in the field pictured here.

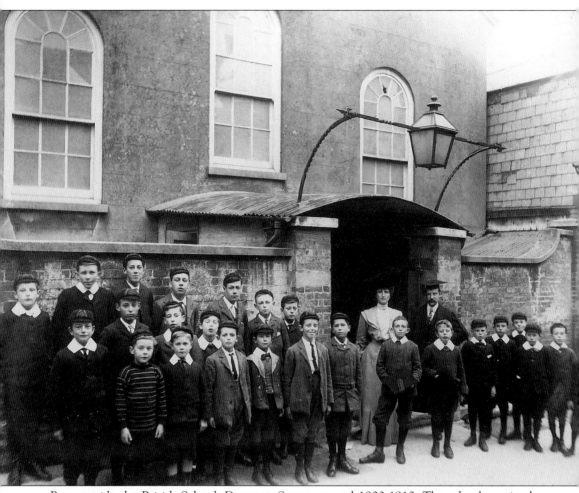

Boys outside the British School, Durngate Street, around 1900-1910. The school was in the Congregational chapel, founded in 1776 and used until 1857 when the new big chapel in South Street was built. British Schools were non-conformist, although many Church of England boys attended because of the high quality of education offered. Thomas Hardy was at the British School between 1850-53, when it was in the Greyhound Yard. In the 1931 recollections the writer remembered being at this school in Durngate Street in the later nineteenth century. The master 'did not believe in sparing the rod. Sometimes he used a ruler – and a stripe across the knuckles hurt'. More cheerfully 'we had two or three good sings every day' and there was a playground. A cricket club was formed, and used Poundbury for its ground.

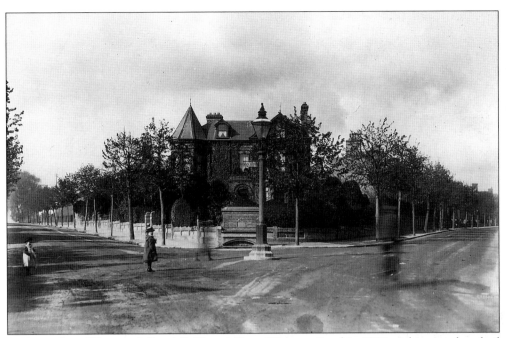

Looking along Weymouth Road (left) and Great Western Road in 1901. A big new detached house makes the corner, and in front is one of the several horse troughs put up in the town by benefactors so that horses might drink. New trees line the roads.

The clock tower in the Borough Gardens under repair, c. 1914. It was given to the Borough in 1906 by Charles Hansford. At the ceremony of starting the clock, M.H. Tilley & Son, who had fitted the mechanism, arranged it so that when it was started the clock rushed through twelve hours, startling the crowd. Originally it was green and gold 'with the various ornamental details having been artistically painted'. The clock or the tower itself must have given trouble soon afterwards, because the photograph shows it encased with scaffolding in 1914.

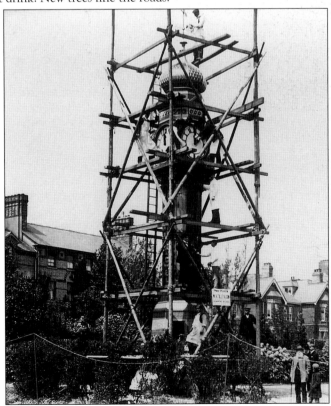

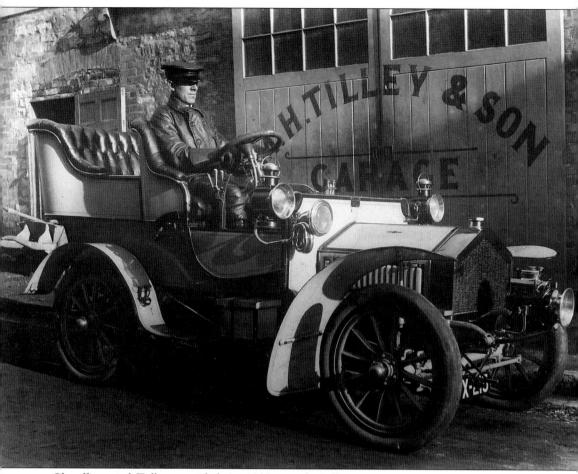

Chauffeur, and Talbot car of about 1903 outside Tilley's Garage in Trinity Street. In 1911
Tilley's were advertising 'Times have changed, and so have the means of locomotion. THE
WORLD MOVES ON WHEELS; We supply the wheels. Wolseley, Humber, Rover, and Ford motor
cars, with any type of body, suitable for pleasure or business'. They also stocked bicycles, baby
carriages and motor bicycles. The latter 'have been vastly improved; they can be depended on
for business purposes and are a most exhilarating means of locomotion'. Doctors were early
converts to cars because they often had to go out to patients at night, and starting a car was so
much easier than harnessing horses. The Fisher's faithful coachman, who had driven the doctor
day and night for thirty years, could not cope with motor-cars, and had to be retired to
gardening.

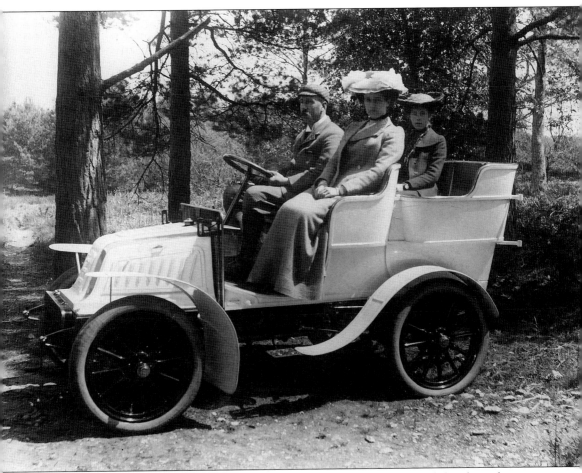

A 1905/6 Humber car, sold by Tilleys, possibly to John Godwin who owned the china shop in High East Street. Like horses, early cars were for sport as well as utility. In 1904 a motor gymkhana was held at Eastbury, north Dorset. To the accompaniment of the Wimborne Town Band so many as forty cars belonging to members of the Dorset Automobile Club ran races, including uphill, bending (a sort of car slalom), and reversing. The most novel was the Ladies Passenger Race, 'In these competitions the drivers had to alight twice and assist ladies into the cars, then drive to the winning post'. Ladies were amongst the drivers and judges, as well as being passengers.

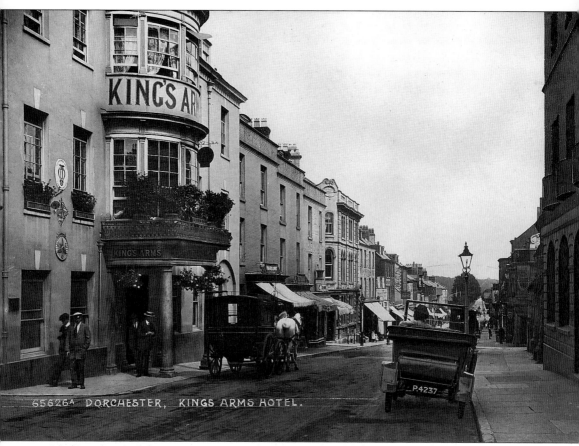

Looking down High East Street in 1913. The car on one side and horse-drawn carriage on the other symbolises the great changes happening at the time. The King's Arms had added an Automobile Association badge (top left) to its frontage and a Cyclist Touring Club badge (below). The King's Arms was itself an innovator. In 1889 it was the first building in Dorchester to be 'lighted with electricity' even though only part of the building was affected. 'By utilising the steam engines' of the Aerated Waterworks at the back of the hotel 'sufficient power is available, to supply twenty lamps'. *The Dorset County Chronicle* predicted that the King's Arms experiment 'will soon be generally followed by the principal tradesmen of the town'. The hotel was also the first place in Dorchester to have a telephone, soon after 1900.

Four
The Great War
1914-1918

'Dorchester is teeming with soldiers, mostly drunk'
Thomas Hardy in a letter, 1914

*'At the German prisoners' camp, including the hospital, operating-room etc., were many sufferers.
One Prussian, in much pain, died whilst I was with him – to my great relief and his own. Men lie
helpless here from wounds; in the hospital a hundred yards off other men, English, lie helpless from
wounds – each scene of suffering caused by the other'*
Thomas Hardy in his notebook, late 1916.

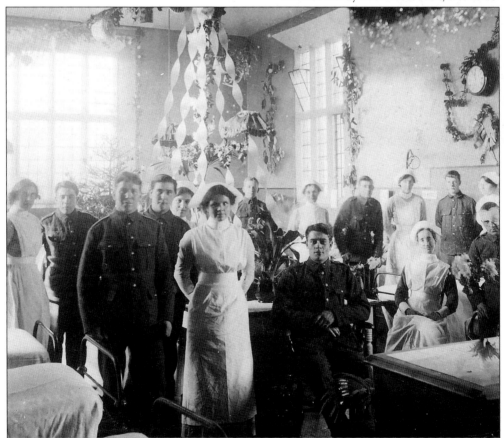

Colliton House V.A.D. Hospital, 1914-1918. The main house was used, supplemented by tents
in the grounds, and in four and a half years 2,006 British soldiers were treated. The tented part
of the hospital looked just like the prisoner guards camp on page 89.

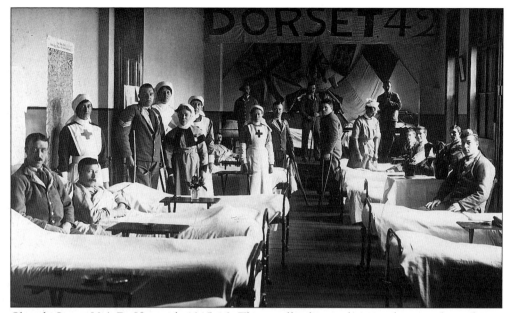

Church Street V.A.D. Hospital, 1915-16. This smaller hospital was only open for eighteen months from 1915. V.A.D. stands for Voluntary Aid Detachment, which was part of the Red Cross.

Soldiers of the Welsh Yeomanry, in the Soldier's Tea and Rest Room, 1915. This was set up in the Corn Exchange during 1915, to provide an alternative to public houses. The banner in the background is from the Church of England Temperance Society: they ran many of the tea rooms. The beautiful singing of the Welsh soldiers was much appreciated. Each Dorchester parish ran the tea rooms for a week in succession.

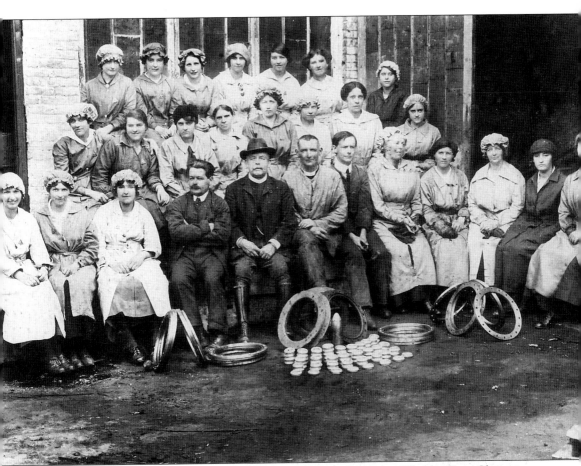

Edward Channon & Son, Motor Engineers, during the First World War. Channons manufactured parts for gun carriages (some visible in the photograph) during the war. Edward Channon is seated centre with a hat, with his sons Ernest (left) and Ralph (right). The workforce is all women, including Mrs Ernest Channon second from the left. Their overalls and mob caps make them look almost like modern factory workers. Doubtless many of their husbands were away fighting in France. 'It is a fundamental truism that the woman's place is in the home; but the cataclysm of 1914-18 effectively disproved of the common assumption that the activities of wife or daughter were limited to the confines made by the four walls of a dwelling house. Today, in the new-found emancipation of women, the prudery and prejudice of Victorian days has been trodden underfoot' *Dorchester Official Guide* 1926.

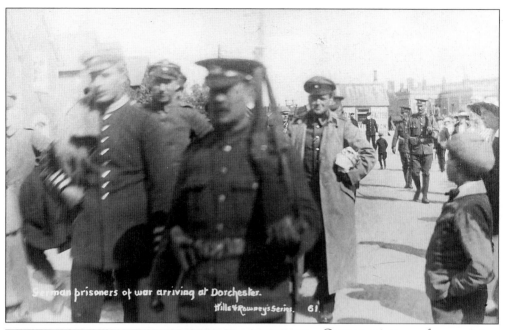

German prisoners of war arriving at Dorchester.

Mills & Rowney's Series. 61

German prisoners-of-war arriving at Dorchester, 1915-18. They are shown coming out of Dorchester South railway station (above) and at the Bridport Road end of Cornwall Road (below). Prisoners were first accommodated in the barrack grounds and later, as their numbers increased, in a huge hutted encampment below Poundbury. People came to jeer when the prisoners first arrived, but on actually seeing the men, fellow-feelings of humanity took over. Dorchester as a whole was sympathetic to the thousands who passed through, and their band was much appreciated. Thomas Hardy visited the camp, and took them German books. By 1916 there were 5,000 prisoners, and Poundbury hillfort was used as their exercise ground, the surrounding banks giving convenient positions for the armed sentries to patrol.

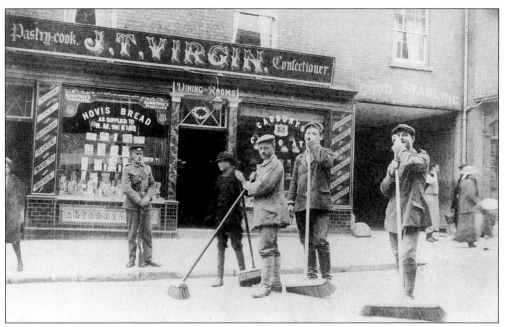

German prisoners sweeping the street outside Virgins, No.15 High East Street. They were also employed lopping trees, working on the farms and in gardens. Hardy employed some at Max Gate, although he regretted that they only received 1d of the 6d an hour he paid for them.

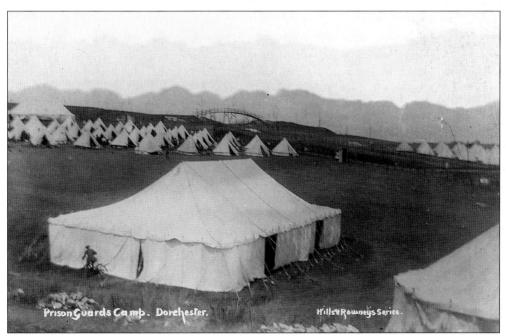

The Prison Guards Camp at Poundbury. All the photographs of the prisoners show them closely guarded (as above). Living in tents must have been hard in the winter.

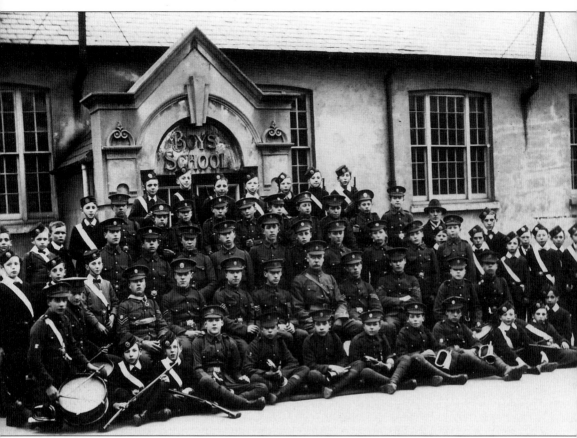

Dorchester Boys' School, Colliton Street in 1915. The oldest of these boys are only fourteen, the youngest eight or nine, and it is a shock to see them dressed in military uniform. The First World War would have been over before they reached eighteen, the age boys could join the Army (although the author's grandfather was told to go out the back and think again about his age when he tried to join up at seventeen: he lied, upped it a year, and was accepted). At the prize-giving in December 1915, one hundred and twenty boys were awarded medals for unbroken attendance during the year, and five received bronze stars for unbroken attendance for five years. Class I sang 'the spirited war-song written by Mr E.W. Riggs, custodian of the Dorset County Offices', and the war was mentioned by all the speakers. One hoped that they would all grow up true Christians, so that when they grew up 'they would be able worthily to uphold the honour and righteousness as well as the strength of the British Empire. God wanted the nation to come out of the present trial better, purer, and stronger than they went into it'.

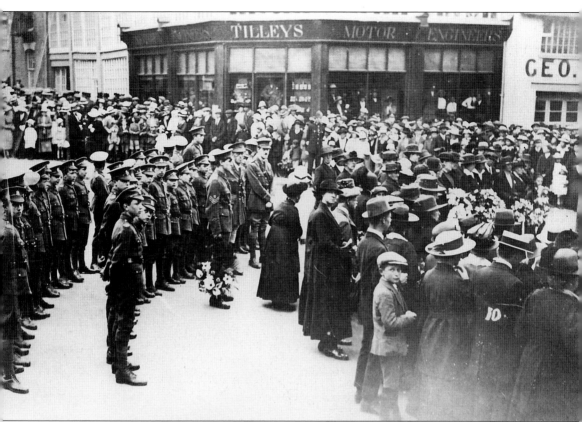

The unveiling of the Dorchester Cenotaph, on Empire Day 1921. The boy soldiers on the left look like the school ones opposite, but were from the Dorchester Grammar School Officers' Training Corps. The seventeen ton Portland Stone block commemorated the two hundred and thirty-seven men from Dorchester who had died in the war. Relatives of those who died were in the front ranks at the ceremony, so the people on the right had all lost someone. They hold wreaths to lay on the cenotaph. Two chestnut trees of the South Walks avenue had to be felled to accommodate the memorial. The Revd H. Bowden Smith, during the address after the unveiling, considered that the cenotaph was not beautiful, 'and perhaps it was chosen for that very purpose, to help all who look on it to realise more fully the hideousness of war'. One in fifty of Dorchester's inhabitants had been killed in the war so 'that the remaining forty-nine might live in freedom'.

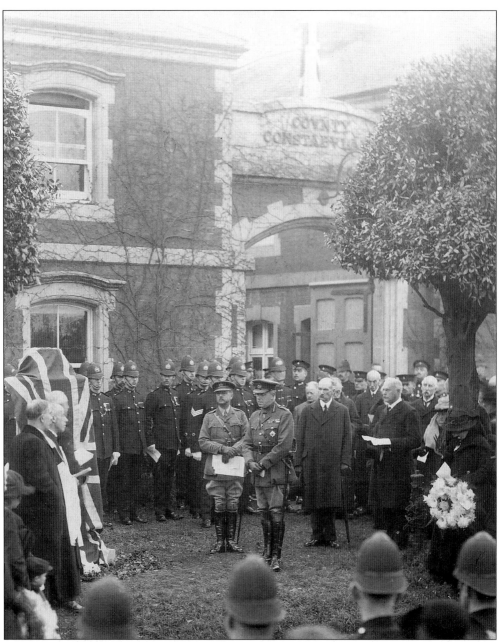

The unveiling of the Dorset Constabulary War Memorial, at the police station, Weymouth Avenue, 1920. Sixty-two Dorset policemen joined the forces during the war, and ten of them were killed. Seven died in France, but the other three show the far-flung scope of the war – they died in Bagdad, Palestine and Mesopotamia. Captain Granville, Chief Constable, is seen centrally with Lord Shaftesbury who is about to unveil the monument. Revd H. Bowden Smith, who gave the address, wore his uniform as a forces chaplain under his robes. Some of the hundred police who attended can be seen in the background.

Five

Peace and
The Great Depression

'This picturesque little town of nearly 10,000 inhabitants has many attractive features. It is very old, yet it is progressive and up-to-date; it abounds in antiquities, and yet it possesses modern features; it is town and yet is country; it has its roots deeply buried in the past, but has none of the aspects of hoary age and decay The Dorchester of today is a bright, trim, cheerful-looking town'.

Official Guide to Dorchester, c. 1930

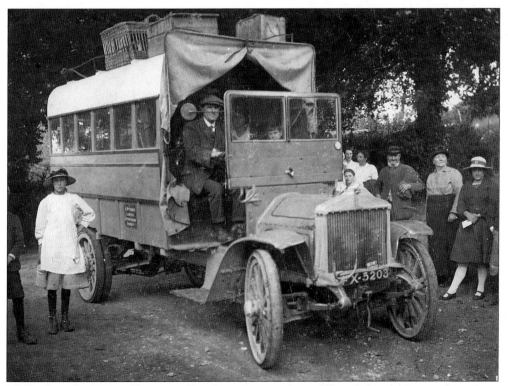

Mr Pitcher, the Litton Cheney to Dorchester carrier (see p58) with his new motor bus, about 1920-25. The internal combustion engine was fast replacing horses on the roads in the 1920s. The carriers were the main link between town and countryside.

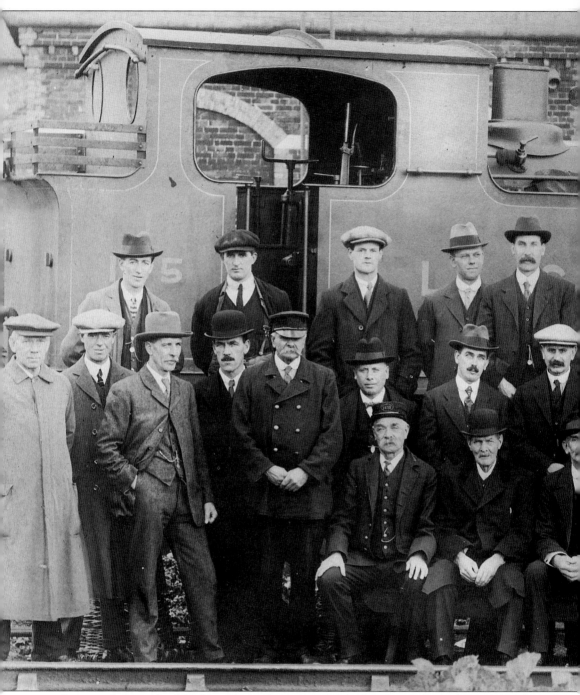

A group photograph of the locomotive department of the London & South Western Railway, October 1919. A letter pasted to the back of the huge original explains that it was sent by the 'Engine Drivers, Firemen and other servants of the L & SW Company, Dorchester Station who remained at work during the recent strike'. The photograph was sent to Revd J. Brymer of Islington House, Puddletown, who had sent each man 'a pair of rabbits in recognition of our standing loyal to our employers'. Despite the large numbers here, some of the men must have

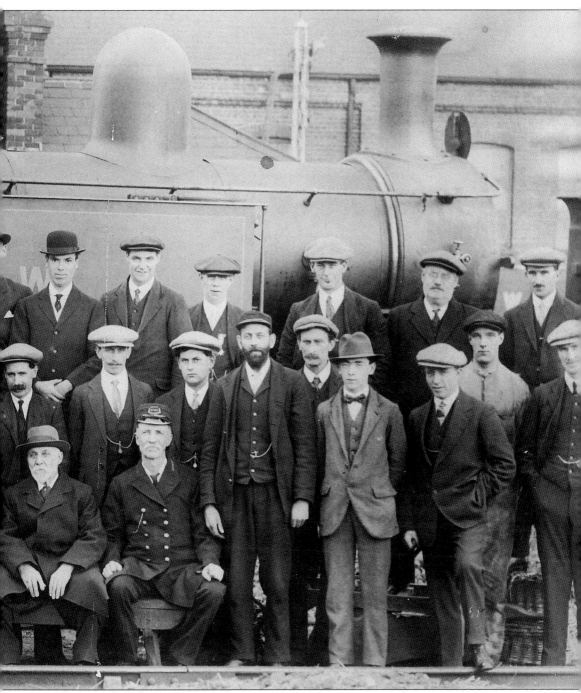

gone on strike, because only a limited train service was possible from Dorchester, and when the first train arrived on the day the strike started, there was 'a slight demonstration from strikers who were on the bank opposite the station'. Soldiers had been posted, along with police, in the station buildings. The strikers attended a Labour meeting in Maumbury Rings on the Sunday. They were asking for better wages, and after nine days' strike, they partially succeeded.

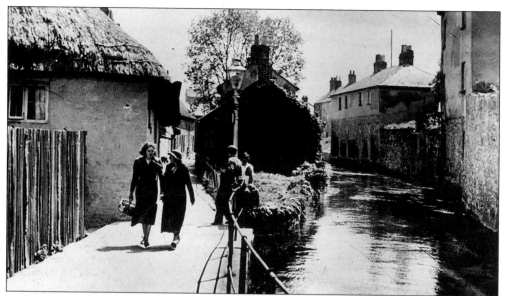

Looking along the river towards Mill Street, Fordington, in the 1930s. The railings along the paths were erected by the Town Council in 1868, and the *Dorset County Chronicle* jovially regretted the immediate abolition of the Mayoralty of Mill Street: 'a person only had to tumble off the narrow footpath into the river, when his installation was complete, and he enjoyed the title "Mayor of Mill Street" until the next unfortunate wight [person] accidentally obtained the necessary immersion and succeeded as a matter of custom to the office'.

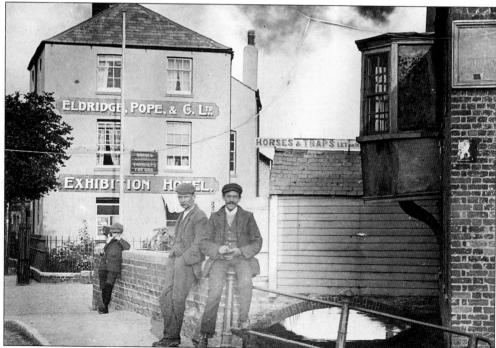

The bottom of High East Street, in the 1930s. The back entrance to the Noah's Ark public house is over the river, and the horses and traps must have gone in and out over the bridge. The road bridge was (and is) a good place for idlers to watch the world go by.

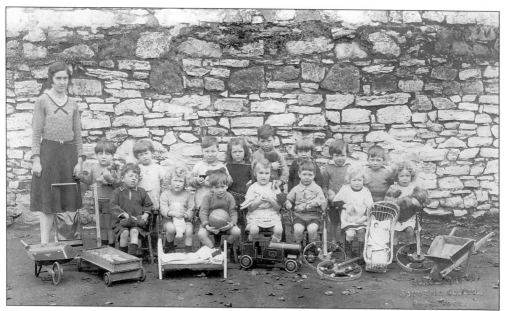

A nursery class at Fordington, 1932. The fine selection of toys out-numbers the children, who are, almost certainly, from St George's infant school. The 1932 annual report for the Dorchester Elementary Schools notes that 'excellent work in junior religious instruction' is being done in Fordington St George's School. 'There is a considerable number of very young children who are receiving valuable lessons for practical application'. These must be those very young children.

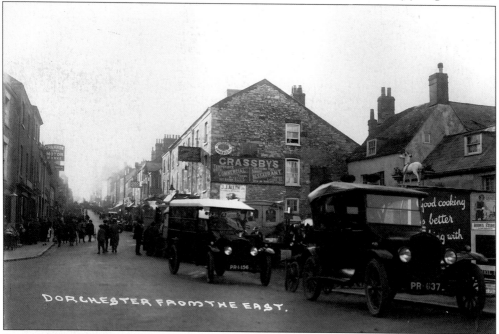

Bottom of High East Street, probably in the 1920s. The crowded streets suggest that this was taken on a market day. The White Hart (right) was one of the bases for the many carriers who connected Dorchester to the villages around. In the 1920s they were changing from horse-drawn vans to motorised vehicles (see p93).

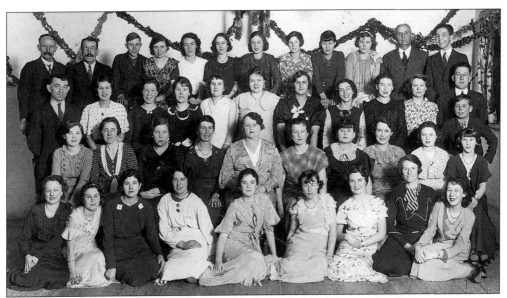

The employees of Dorchester Steam Laundry dressed up for their annual dance, 1920s or early '30s. In 1932 the new year's party at the laundry was reported in the *Dorset County Chronicle*: 'the commodious packing and sorting rooms had been transformed beyond recognition by most attractive decorations ... Harry Crocker and his band [opposite] were responsible for the necessary music'. The Steam Laundry was established in 1879, and was still thriving in the '20s. Their advertisements often mentioned their extensive open-air drying grounds. The building in Bridport Road still survives, but is now a garage.

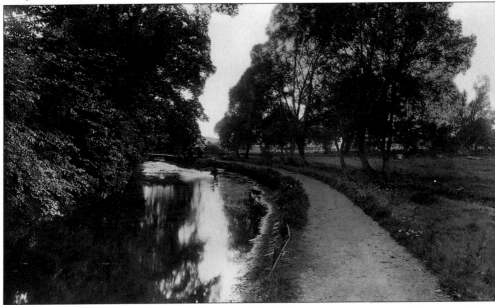

Along the River Frome below Dorchester, 1922. This popular Dorchester walk has never been fenced off from the river, unlike Mill Street (see p96). A man drowned here in 1910, and the jury at the inquest demanded that either railings be put up, or the path entirely closed off. The man must have fallen into the river after dark, and was found dead at Friary Mill Hatches. It was the second time he had fallen into the river whilst using the path at night.

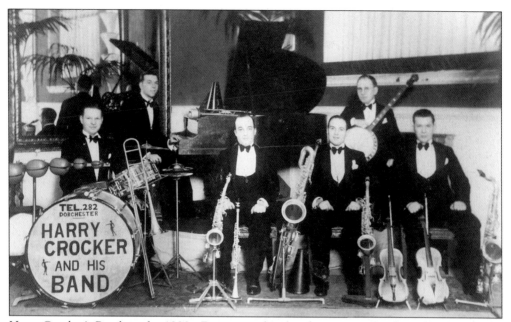

Harry Crocker's Band, in the 1930s. Dancing to live bands was a regular thing from the 1930s, and Harry Crocker's was one of the leading west country bands. It was founded by Harry Crocker (on drums) in 1928 and continued into the 1960s. Harry Crocker's tobacconist and confectioner's shop was in High East Street from 1927 until his death in 1971.

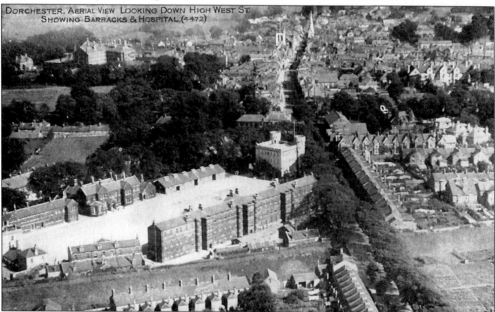

Dorchester from the air, in the early 1920s. Air views were a novelty then, and many postcards were made from them. This one is looking east from the Bridport Road, along the High Streets. The Barracks are in the left foreground (the big block in front was demolished in 1958). The trees of the Walks make a clear line across the middle of the photograph. St Peter's tower and All Saints spire stand up out of the lower buildings in the town centre. To the right is dense late Victorian housing development.

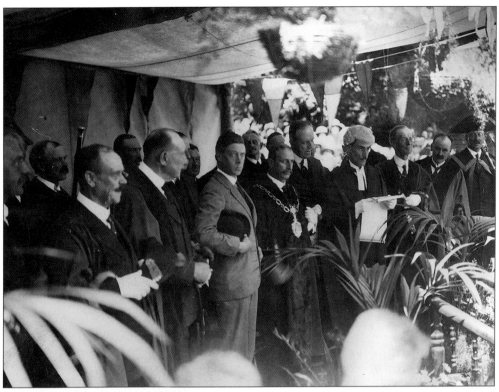

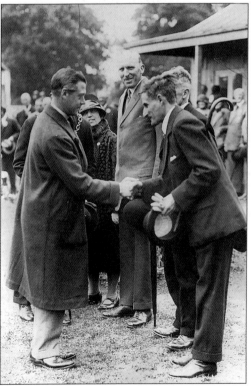

The Prince of Wales in the council pavilion, Dorchester, in July 1923. Prince Edward, then aged thirty, was extremely popular, as the people crowding in Boon's first floor windows demonstrate (top picture on opposite page). He was to abdicate the throne thirteen years later. The council pavilion was decorated to look like a garden. In the top photograph Adrian Hands (with his legal wig on) is reading an address. *The Dorset County Chronicle* reported that the visit caused 'the biggest gathering of Wessex folk in Dorchester for a quarter of a century. All the countryside had flocked into Dorchester to see the Prince. Some left far-distant hamlets soon after early dawn and tramped to Dorchester'. The Prince was driven through the middle of town to the pavilion, where he was presented to borough officials. Left, he is shaking hands with Adrian Hands, the Town Clerk. The weather looked like rain, which accounts for the umbrellas.

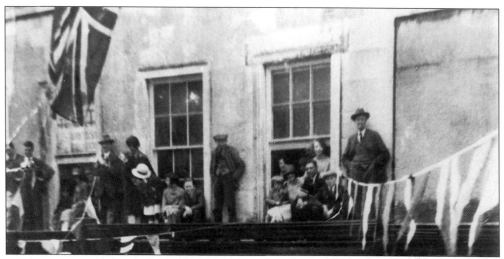

South Street getting ready for the Prince of Wales' visit, July 1923. The spectators getting into position to see the Prince are standing on the narrow ledge over Boon's shopfront, or crowding the first-floor windows. In the right hand window is the Shepperd family.

The WI Pageant in Colliton Park, July 1929. Roman soldiers approach an altar. Later a chorus of Vestal Virgins ceremonially blessed a house. Thousands of people saw the performance, which illustrated Dorset's history from Roman to Georgian, and included nearly five hundred performers.

At the German war memorial in the 1930s. Forty-four German prisoners-of-war died in the camp at Poundbury, all except one of wounds or disease. One was shot whilst trying to escape. They were buried in Fordington cemetery and the memorial seen here was carved in the prisoner-of-war camp in 1919. The Mill Street Mission (see p76) visited this memorial on Armistice Day 1926, to lay a wreath with an inscription about their own twenty-first anniversary and Germany's entry into the League of Nations, 1926. The Mill Street Mission was very internationalist in the 1920s and 30s, and worked with peace movements.

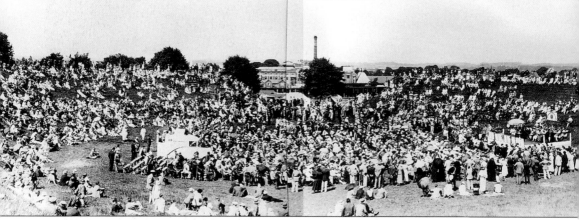

Panorama of the Peace Pledge Union meeting in Maumbury Rings, 1936. Newspapers estimated the crowd at between eight and ten thousand, far larger than any of the other meetings like coronation celebrations held in Maumbury and the largest Peace Pledge Union meeting ever held. Vera Brittain (one of the speakers) described this meeting in *Testament of Experience* (1957), remembering the huge audience and the burning heat of the day.

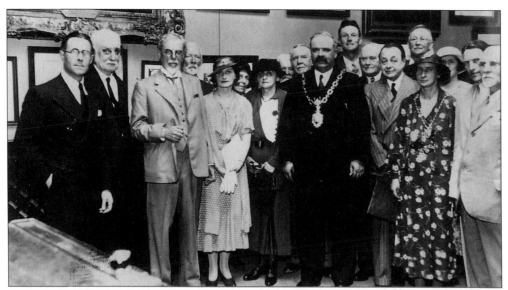

Posing before the lunch at the town hall for delegates to the Peace Pledge Union meeting, 1936. From left to right: Donald Soper, George Lansbury, Laurence Housman (chairman of the meeting, writer, brother of the poet), Vera Brittain, Mayor of Dorchester (F.C. James), Dick Shepherd. The Peace Pledge Union was founded by Dick Shepherd in 1934, to try to prevent another war. Members signed a pledge: 'I renounce war and I will never support or sanction another'. At the meeting in Maumbury Dr Donald Soper declared that 'Non-violence was more than a refusal of war: it was God's rule for the whole of life'. Vera Brittain 'spoke of the horrors of the last war, and said that if they did not get organised for peace they would be confronted with a worse catastrophe still'. George Lansbury spoke of the League of Nations, whose first and primary duty was to remove the causes of war. Dick Shepherd wanted a million people to sign the pledge against war.

The speakers at Maumbury, 1936. From left to right: George Lansbury, veteran labour MP; Dick Shepherd, founder of the Peace Plegde Union; Donald Soper who represented the non-conformist churches; and Vera Brittain, author and reformer.

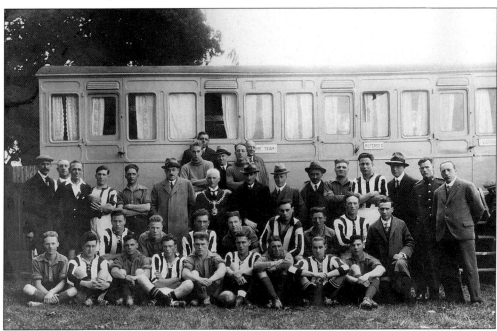

Dorchester Town Football Club outside their new premises in October 1929. The formal opening of the new ground off Weymouth Road had just taken place, Dorchester won its first match there that day (against a team from the Dorset Regiment) 2 - 0. The labels on the old railway coach read HOME TEAM, REFEREES & VISITING TEAM. The mayor, E.W. Tilley, and many of the Corporation are in the photograph with the football team.

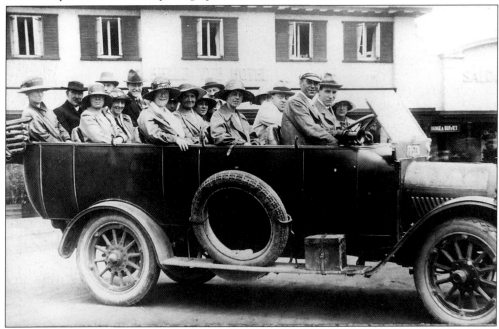

The Congregational Choir outing to Bournemouth in 1921. Motor charabancs like these were popular for trips in the 1920s. A big hood (just visible at the back) could be drawn over if it rained. Beside the driver in the front row are Mr and Mrs Rex Fare.

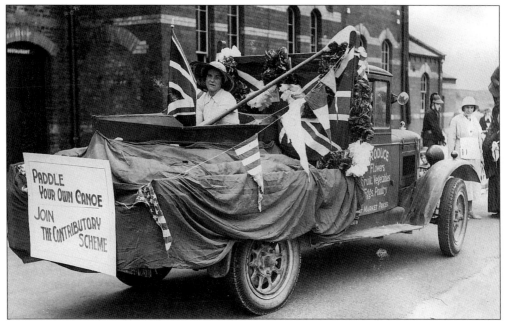

Carnival float at the Barracks, almost certainly one of the two hundred and twenty entries in the Silver Jubilee Carnival in 1935. In the autumn of 1934 a young German woman who was canoeing around the whole British coastline made news at Weymouth when the race off Portland Bill gave her problems. The float must be a reference to the German, and is probably advertising the Dorset Working Women's Club whose contributory scheme was an insurance for doctors' bills. Dorchester did not have annual carnivals in the 30s, so the Silver Jubilee procession was a novelty which attracted thousands of spectators.

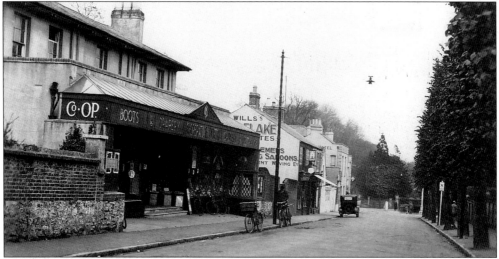

Great Western Road in the 1930s. The large Weymouth & District Co-operative shops opened here in 1920. In the late nineteenth century there was only one shop in Great Western Road, but by 1926 there were six or seven, all on the north side of the road. The 'BOOTS' on the fascia board indicates part of the stock, not the owners. The shop has been added onto the front of a big house. Beyond the Co-op is Parson's the hairdressers, with their tobacconists shop next door.

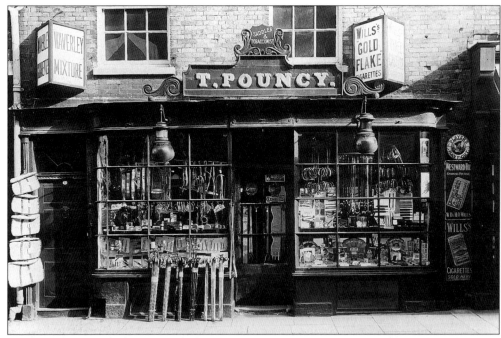

Pouncy's saddler and tobacconist, No. 3 Cornhill, in 1920. The shop front was constructed about 1830, by Thomas Pouncy who established his shop here in the early nineteenth century. Besides making saddles and harness, the business at different times provided a servant's registry and collected taxes.

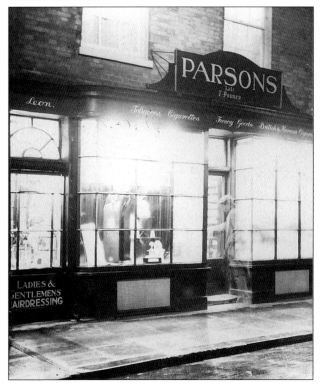

The shop at No. 3 Cornhill, c. 1937. About 1936 the shop was sold to W.C.L. Parsons, hairdressers and tobacconists of Great Western Road (see p103). By 1939 he also ran a fourth shop at No. 32 South Street. Pouncy's shop was modernised, happily keeping most of the old detail, but altering a side door to make a separate entry to the hairdressers, which replaced the saddles and bridles. It was very lucky for Dorchester that Parson's preserved the old shop front – elsewhere in the town in the '20s and '30s much was demolished to make way for new plate-glass shop fronts. The 1930 *Town Guide* quoted at the head of this chapter shows one of the problems for the town then, it wanted to be both picturesque 'olde-worlde' and up-to-date.

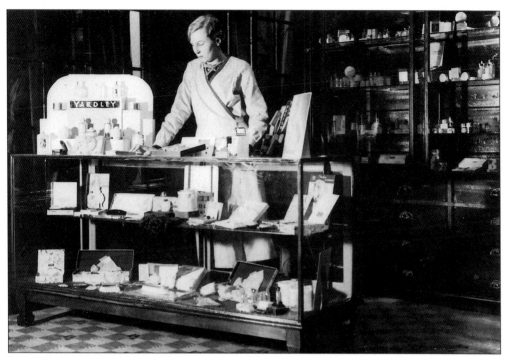

Inside the hairdressing part of Parson's, No. 3 Cornhill, 1937. The woman behind the very up-to-date cosmetics counter has a very modern hair-style. In 1938 Parsons were advertising 'Eugene Aerogene (4 volt - safe as a Marcel Wave)' evidently another method of producing the fashionable curled effect.

Inside the tobacconist part of Parson's shop, No. 3 Cornhill, 1937, Mr F. Amey is behind the counter. This area is dedicated to pipes and loose tobacco, some of it in the ornamental jars. Cigars are on the counter in their own display boxes. Another photograph shows a big bay with packets of cigarettes. Proper tobacconists like this one always smelt wonderful: fragrant from many tobaccos.

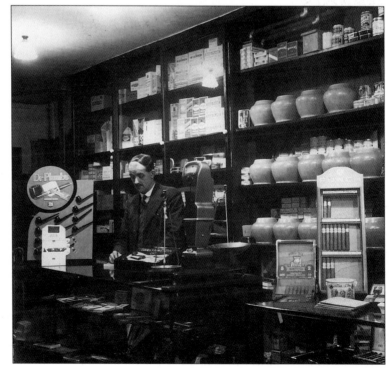

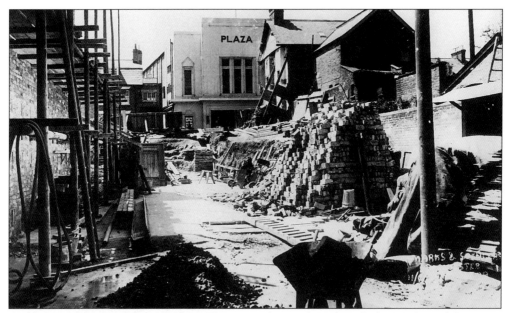

Building work in South Street, 1936. The area is being cleared ready for Marks and Spencer's shop. Because this popular shop was in South Street, many others moved in to the area, accelerating the decline of shops in the High Streets. In the background is the Plaza which opened in 1933. The concrete and steel cinema was a novelty for Dorchester – the most modern building in the county, according to the local paper. It still survives as a cinema.

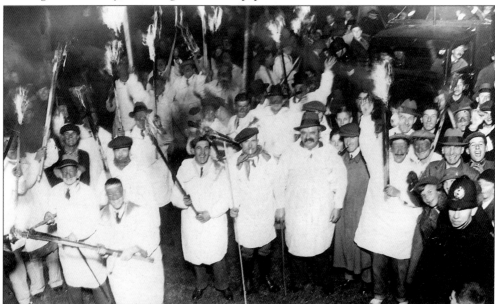

Fifth of November celebrations, 1935. Up to about 1900 Dorchester celebrated the 5 November in great style, with a big bonfire on Poundbury and other jollifications. These were revived in 1935 by the mayor, Mr F.C. James, seen in the centre of the photograph with a big hat. Smock-clad torchbearers led the town band from Fordington Green to Poundbury, carrying an effigy not of Guy Fawkes, but 'Mr Killjoy' who was burnt on the Poundbury bonfire. Thousands of people attended the celebrations, which were repeated in 1936 and 1937.

Six

The Second World War

'.... with the lifting of the ban we became flooded with evacuees. I spend day after day conferring with Public Assistance, Relieving Officers, Billeting Officers, WVS ladies; and hastening from one Rest Centre to another saying words of comfort such as; soap flakes can be made out of solid soap by means of a cheese-grater, nobody need be ashamed of lice nowadays, salads will not be appreciated without vinegar, Londoners seldom like porridge, pubs open at six, nettle stings are not the same as nettle-rash, fish and chips will come out in a van, lost prams shall be traced, those are our planes, Londoners can't be expected to go to bed before eleven, the old lady will probably leave off crying if you can get her to take her shoes off, cows don't bite, have you put up a washing-line, nursing mothers must have early morning tea, buses run on Wednesdays and Saturdays, etc......

Sylvia Townsend Warner in a letter, July 1944

Dorchester children on an American jeep in Charles Street, 1945. John Hallet (left) remembers the American officers visiting the Conservative Club and giving the children pennies.

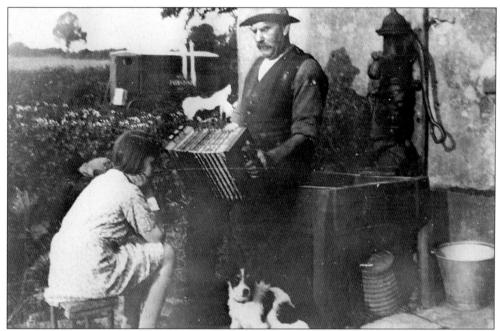

Ben Fowler of Coker's Frome in 1941. With so many Second World War photographs of young soldiers, evacuees, and so on it is easy to forget the part the elderly and middle-aged played in the war. Anyone over forty had already lived through a World War, and many elderly agricultural workers contributed greatly to the war effort in food production. Ben Fowler was presented with an Award of Merit in December 1942 by the National Union of Agricultural Workers, for long and faithful service.

Ben Fowler in 1942. He is shown with his awards, which included a silver medal for thirty years continuous membership of the Union. He was proud of his honour, and always ready to tell of the improved working conditions the Union had brought about in his lifetime. Agriculture was Dorset's most important war industry. In 1939 more than two-thirds of Britain's food was imported: by 1943 imports had halved.

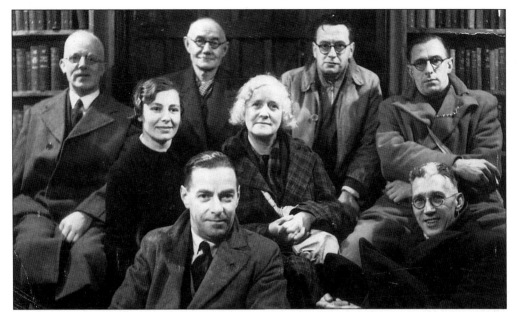

Fire watchers in the library, Trinity Street, during the Second World War. Air Raid Precautions and Civil Defence were set up even before war was declared, and having people in each area and all large buildings ready to put out fires caused by bombing was a vital part of ARP. Dorchester had very few bombs, but one did fall in Trinity Street, not far from the library. It made a big crater in the road and burnt out Mr Fry's bakery.

Evacuees in Dorchester, 1939. In September 1939 Dorset had 10,468 unaccompanied 'official' evacuees: there were at least as many more private evacuations. Official evacuees were billeted on local families, who had to take them. Most returned to London when the expected immediate bombing did not happen. From left to right: Jennifer, John, Kenneth, Christine, Bernard and Kathleen Rains. Later Dorchester became a restricted area, not considered suitable for evacuees. The quotation at the head of the chapter related to a new flood of people in 1944; the novelist Sylvia Townsend Warner was working for the Dorchester WVS office.

Arthur Daniels, milkman in the early 1940s. Arthur Daniels lived in Colliton Street and was a member of the Salvation Army. His delivery method would have been familiar to the Victorians; a yoke over his shoulders to spread the weight, and lidded cans from which he poured the milk into customer's jugs or cans.

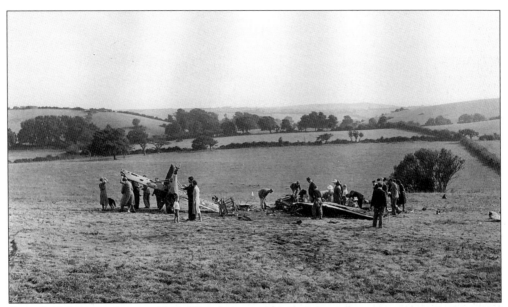

A crashed German plane, c. 1940. The photograph is thought to have been taken from north of Poundbury. The Observer Corps (see p118) were a vital part of the chain leading to the destruction of enemy aircraft – the accurate and up-to-the-minute information they supplied enabled the RAF to get into the right positions to attack the enemy. Crashed planes, especially German ones, were great attractions – everyone wanted a souvenir.

The Dorchester Building Guild at the Steam Laundry, September 1940. The firm must have rebuilt the chimney as the printed caption to the original photograph states that it was 63ft 3in high. The summer of 1940 was the time of greatest peril for Britain, German invasion seemed imminent, the Home Guard were formed, and all the country was on alert. The photograph reminds us that work (even building work) went on through those desperate times.

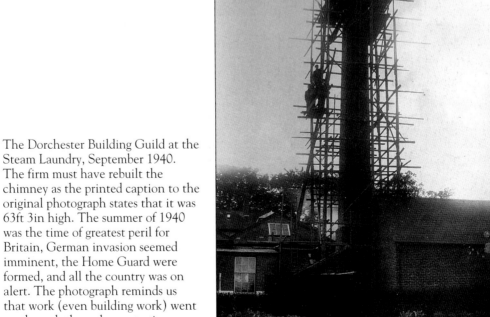

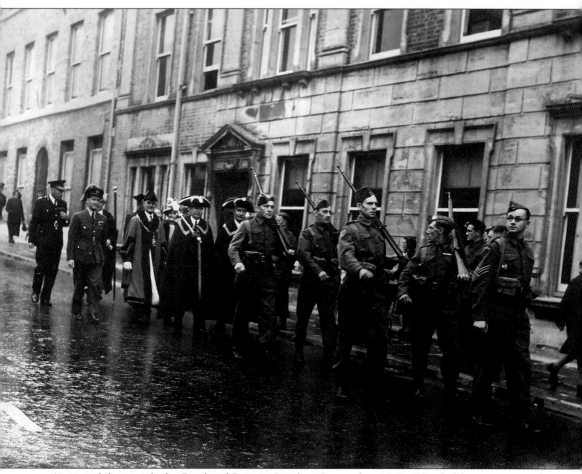

A part of the parade for Battle of Britain Sunday, September 1943. 'Headed by a regimental band, units of the RAF, WAAF, ATS [Auxiliary Territorial Service: the women's army], AA [Anti-Aircraft] Batteries and the Royal Observer Corps marched through the town with the borough Civil Defence contingent' to a service held in the Plaza Cinema. The mayor and mace bearers (background) were preceded by the Home Guard as they came down High West Street. The Battle of Britain followed the evacuation of British Forces from France, at Dunkirk: the moment when invasion of Britain was most likely. The RAF (the few) succeeded in preventing Hitler gaining the air supremacy he needed to invade. Dorchester had been more involved in the aftermath of Dunkirk: as a barracks town it was filled with exhausted soldiers, some of whom slept in the streets for lack of any shelter. The Home Guard was established in 1940, at the time of the Battle of Britain, as part-time local defenders against invasion. *The Dorset County Chronicle* described the local Home Guard in the Autumn of 1940: 'to outward appearance they are soldiers. Their clothing, and – latterly – even their equipment is identical, but here is a free-and-easy atmosphere about their enthusiasm that is manifest in their ultra-democratic outlook'. By 1943 they had become rather more formal, but somehow they still don't look like 'proper' soldiers.

The Charminster Cubs in camp, 1943. Rabbits were caught to help eke out the rations, and here the boys prepare them. Dickie Manning decapitates with a bill-hook; John Raves skins one; John Costin (an evacuee) has a bowl of water; Edwin Hawker holds up a victim; and standing behind is Roy Paul. They couldn't have a camp-fire because of black-out regulations, and some of the tents were camouflaged.

The drive at Max Gate, winter 1940. Thomas Hardy had been dead for twelve years, his second wife only three. Max Gate belonged to Hardy's sister Kate (who herself died in 1940). The house was let to Brigadier Parham: two of his daughters sledge in the drive. The Parhams had moved to Dorset because of the war, and rented the house from Kate Hardy. It was difficult to find houses to rent because so many people were moving out of London and other cities. Even famous houses like this one were put to use. The Parhams shared Max Gate with a succession of other families.

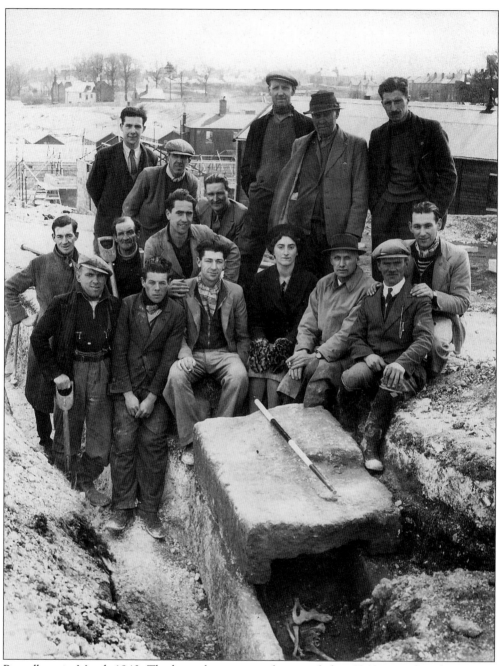

Poundbury in March 1940. The barracks were greatly extended in 1940, to make a large army camp of big huts. The area had been a huge Roman burial ground, and three Roman stone coffins were found in 1940. This one was discovered during the digging of a water-main. Col. C.D. Drew (sitting second from right) the curator of the Dorset County Museum oversaw the excavation. His daughter is next to him, and the others must be the workmen constructing the camp.

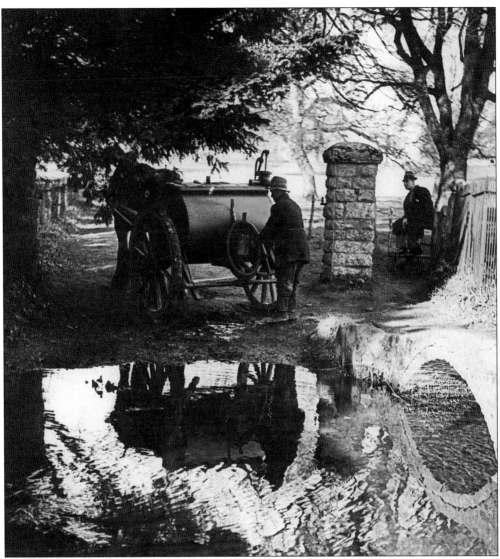

Taking water from the river, 1940. The water cart looks like those manufactured by Lott & Walne (see p72). The water was probably going to be taken to cows. Few fields had piped water before the war, and watering animals was a constant task. The photograph was taken near Frome Whitfield House in the water-meadows north of Dorchester.

The Observer Corps Post at Poundbury, *c.* 1940. The defences of the Iron Age hill fort re-used for modern warfare. The telephone pole was vital for communication of the observations, but seems odd for a hill fort (it could have transformed war in the Iron Age). The post was first manned on 24 August 1939, a week before war was declared.

Looking out of the Observer Corps post on Poundbury, *c.* 1940. The wide views from the hill fort show why it was chosen. On the horizon right is Dorchester's water tower, and on the left the twin towers of the barracks keep. On the side of the post are cards showing planes from many aspects, for identification purposes.

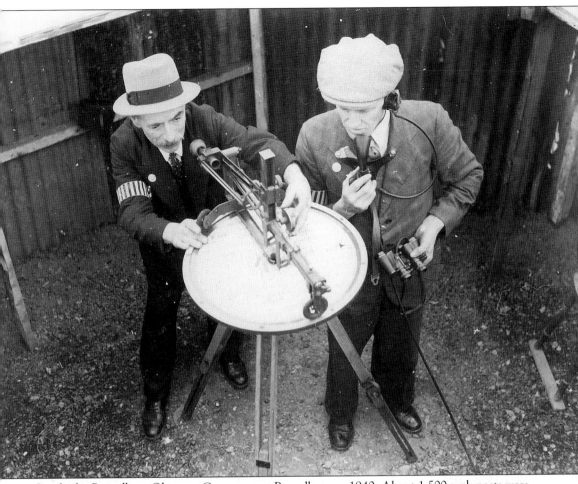

Inside the Poundbury Observer Corps post at Poundbury, *c.* 1940. About 1,500 such posts were manned throughout the war to supply information on all aircraft movements to the RAF. Radar detected planes coming over from Germany, but the Observer Corps supplied much more detail. They were in constant contact by phone with the centre at Yeovil (as here) giving identification of the planes, their height, speed and direction. The other man works the Micklethwaite range finder to calculate the position of the plane. The posts were manned by part-time volunteers, all local, who had to undergo intensive training and who worked at the post as well as doing their normal jobs. The man with the telephone is probably Don Harding.

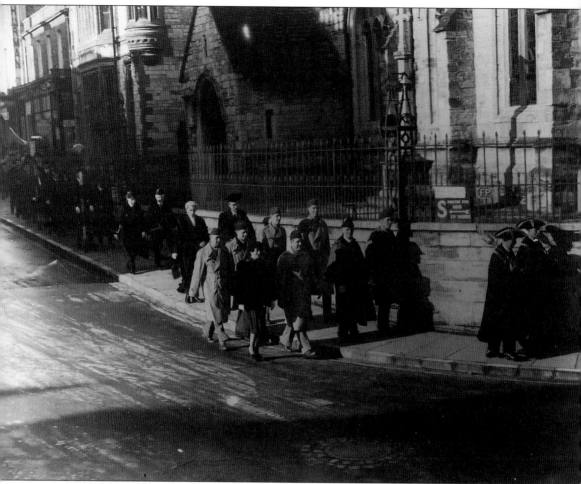

American Army officers in the procession for Mayor's Sunday, outside St Peter's Church in the winter of 1943. The sign with the large 'S' shows that there is an air-raid shelter for one hundred people, thirty-five yards up the road, probably in a cellar. American soldiers arrived in Dorset in the summer of 1943, and by early 1944 there were 80,000 American troops in the county. In January 1944 Dorchester's mayor held a civic reception for the officers and men at the Plaza cinema. The mayor claimed that local children were disappointed with the Americans at first, because the children's knowledge of America was based on films 'and they were led to think you were going to arrive in Wild West cowboy kit, with sombreros and six-shooters'. The children soon adjusted. Many of the Americans who trained in Dorset died on D-day because they were part of the assault on Omaha beach, the most difficult part of the assault.

Captain Robinson and his driver Paddy with Mrs Parsons at Edward Road in Summer 1944. Captain Robinson (known as Long Tom) was a vehicle dispatcher in the American Army, organising transport for troops and equipment through Weymouth to France. Wounded, refugees and prisoners-of-war came to Weymouth from France in the empty ships which had taken the military out.

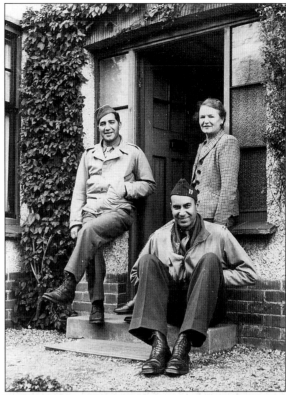

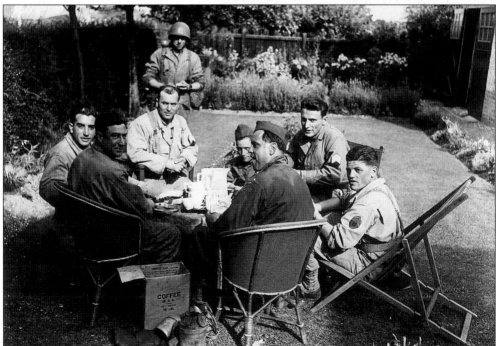

Free French soldiers take tea in the back garden at Edward Road, late July 1944. The Free French followed through after most of the Americans had left, using the same camps.

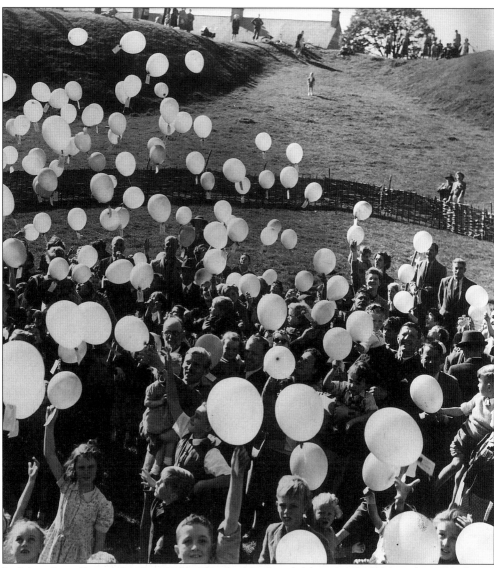

In Maumbury Rings, October 1948. Two hundred and fifty school children let off balloons carrying messages letting the world know about the Dorset Industries Exhibition which was about to open in Dorchester. The children and the balloons make a good symbol for the hopes of the post-war world. Never again was there to be war. Poverty and disease were going to be abolished, education was to be free, good housing was to be built for everyone, and the world was going to be a much better place. *The Dorset County Chronicle* reported that all the balloons were let go at a whistle signal 'and the coloured balloons rose majestically into the air and slowly gained height. One or two wavered for a moment before joining the others, but soon all were floating high over the houses of Dorchester to carry the message of Dorset's enterprise to all corners of the country'.

Seven
The New Elizabethans

'I feel confident, Mr Mayor, that the Corporation of your ancient borough, while seeking to preserve the legacies of the past, will equally satisfy the needs and aspirations of the present'.
HM the Queen, in her speech at Maumbury Rings, July 1952

'We can show you a history second to none and today a shopping centre of high quality and great variety, with the proprietors and their staffs highly trained in the skills and mysteries of their trades'.
From the handbook – *Dorchester through the Ages*
Shopping Week 25-30 August 1952

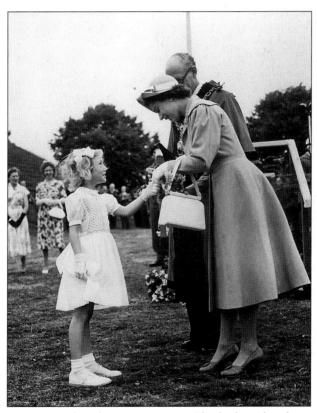

Eight year old Margaret Woodward presents Queen Elizabeth with a bouquet in Maumbury Rings, July 1952.

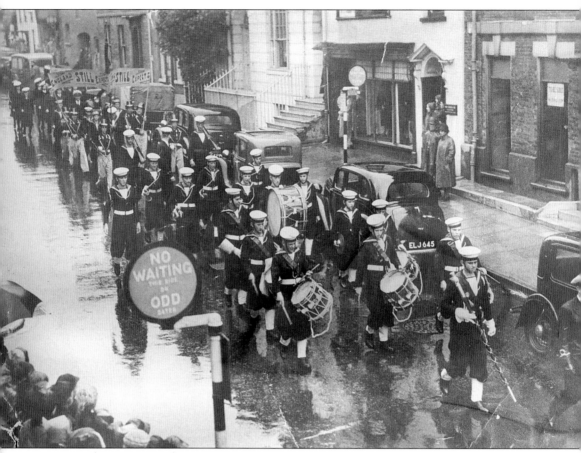

A parade in a wet High West Street, September 1949. The Sea Cadet Corps (with band and banner reading 'England still expects') are part of the Dorchester Chamber of Commerce Shopping Week celebrations. Parking was already a problem, with the sign reading 'no waiting this side on odd dates'. The Sea Cadets, the Durnovaria Silver Band and a column of soldiers with mechanised artillery led the mile-long procession of floats, Dorchester's first post-war carnival. Two inches of rain fell that day, the most on one day since 1930. The carnival was part of 'shopping week' to promote local trade. One of the prize-winners was Dorset County Agricultural Executive Committee, with a demonstration of bee-keeping. Perhaps it was lucky that it rained bees on a lorry all through the town sounds menacing. Messrs Tilly entered a 1909 Austin driven 'in stops and starts by characters in period dress'.

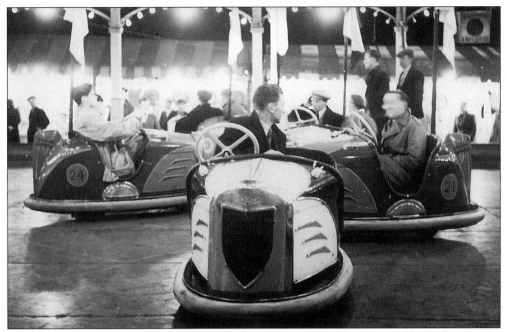

Dorchester Fair, probably late 1940s. The dodgems are very stylish, with stream-lining. Funfairs were part of the real fairs for selling sheep, cattle and so on until the twentieth century, when they occurred on their own.

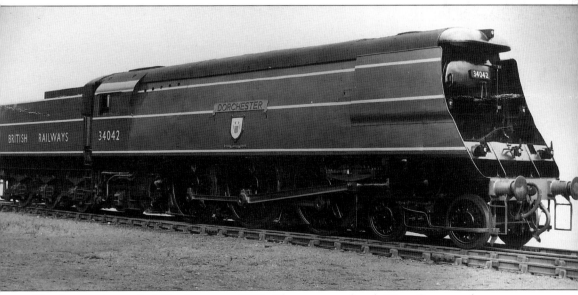

The locomotive called *Dorchester*, c. 1948. These stream-lined West Country class steam locomotives had a distinctive profile which led to the nick-name 'Spam Cans'. Whilst the stream-lining improved performance, it impeded maintenance, and many of these locomotives had much of it stripped off in the 1950s.

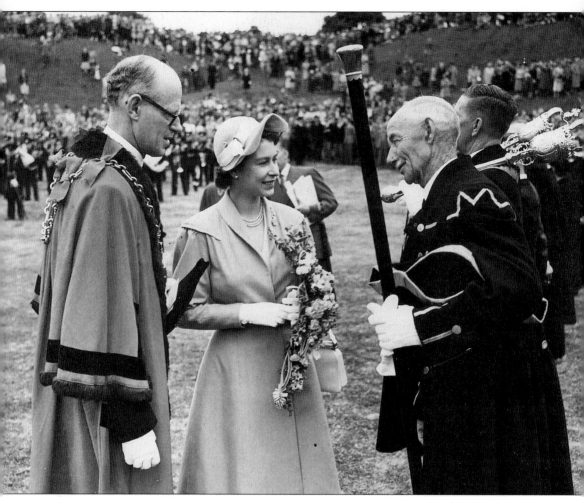

Queen Elizabeth, Maumbury Rings, July 1952. She had become Queen in February that year (aged twenty-five) but had not yet been crowned. She was visiting Duchy of Cornwall estates and was welcomed by a triumphal arch in Great Western Road. E.L. Hedger, the mayor (left) delivered the loyal address in Maumbury Rings and afterwards presented the Queen to members of the town, rural district and county councils. Here she speaks to one of the Borough mace-bearers. Both bearers have the fine silver gilt ceremonial maces of 1728 over their shoulders, and one holds the eighteenth century ceremonial staff.

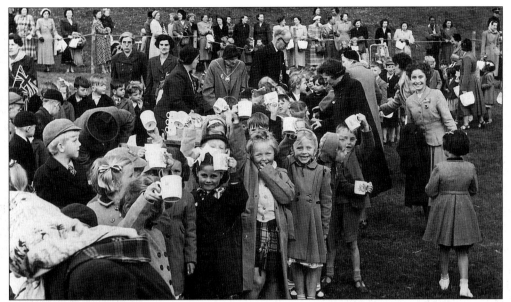

At Maumbury during the coronation celebrations, June 1953. The junior schools went to Maumbury Rings, while the older children participated in Coronation Sports Day at the Recreation Ground. The juniors were entertained by two Punch and Judy shows, a conjurer and a dancer, followed by tea 'There was excitement in the ranks when the mayor and mayoress arrived to present each child with a souvenir Coronation mug'. The excitement is caught in the photograph.

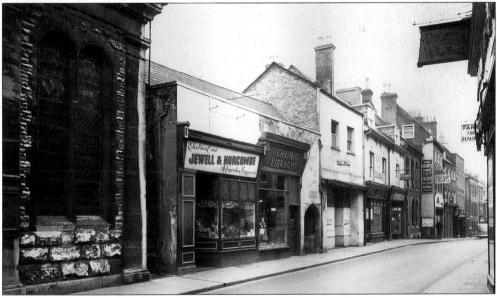

South Street, c. 1952. The three shops on the left are about to be demolished to make way for a shopping arcade. They fronted the Greyhound Yard (where Hardy had attended school in the 1850s). The sixteenth century arch making the entrance was re-set in the new development (and has since been re-set again). Dorchester suffered comparatively little from the 1950s mania for rebuilding, although it did loose some fine 1930s buildings like Thurman's shop in South Street, an Art Deco beauty.

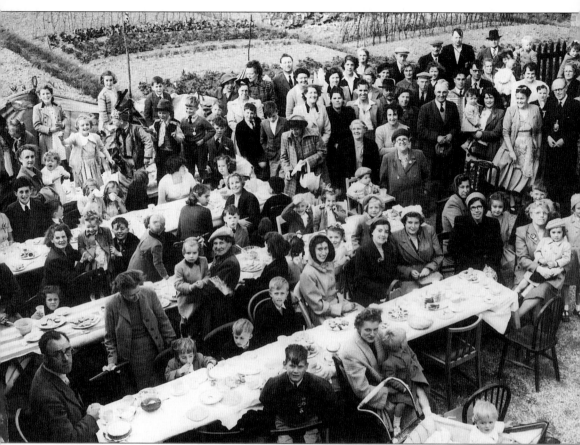

Alfred Road Coronation party, June 1953. Many areas of the town held street parties for the coronation (or C-day as the newspapers called it, in imitation of D-day). At Alfred Road fifty-four children were given tea, and afterwards each was presented with a bag of sweets (which had only come off ration four months earlier) and a souvenir. Boys received a pen-knife, girls (rather oddly) a teapot, younger children a propelling pencil and, tiny tots a medallion. At Alfred Road there was dancing in the street, in the evening, to a piano. The Queen's speech was broadcast in the Borough Gardens, and after dark a huge bonfire was lit on Poundbury. One of the steam engines which had taken part in the carnival procession was driven into Poundbury and its bright lights added to the festivities. Even after the bonfire died down, Dorchester was still celebrating. The Coronation Dance at the Corn Exchange went on until 3 a.m. Special arrangements had been made for viewing the Coronation live on television. These were still very uncommon, but 'thanks to the ingenuity of the television technicians of Messrs Rogers and Dawes, nearly two hundred and fifty old people of the town' saw the 'whole of the five-hour programme on 5ft by 3ft screens' set up at each end of the Corn Exchange. The technicians 'were on hand to deal with any emergency'. Elsewhere people crowded round the tiny contemporary sets, lucky to get a glimpse.